DRAWING GALLERY

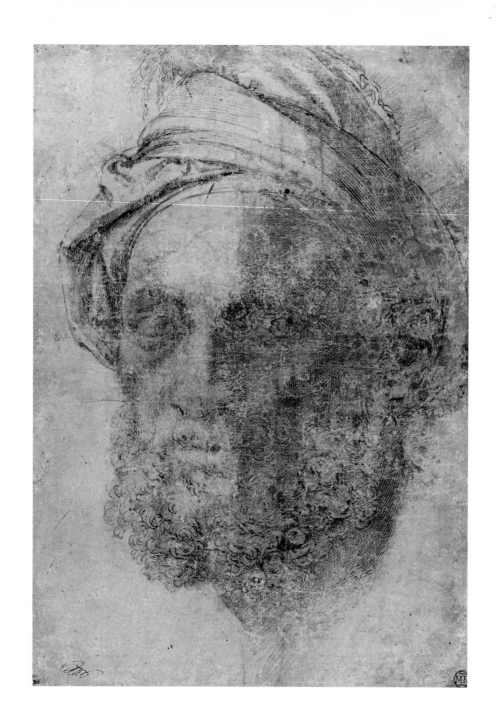

LOUVRE

DRAWING GALLERY

Michelangelo

Paul Joannides

CONTINENTS

Cover
Michel-Ange, *Resurrection of Christ,
with nine guards* (see pl.54).

Frontispiece
Baccio Bandinelli, *Portrait of Michelangelo*,
pen and brown ink. 365 mm x 250 mm.
Paris, Musée du Louvre, Inv. 2715.

For the Musée du Louvre :

Editorial Coordinator
Violaine Bouvet-Lanselle

Iconography
Carole Nicolas

© Musée du Louvre, Paris, 2003
© 5 Continents Editions srl, Milan, 2003

http://www.louvre.fr
info@5continentseditions.com

ISBN Musée du Louvre : 2-901785-47-6
ISBN 5 Continents Editions : 88-7439-036-X

For 5 Continents Editions :

Art Director
Fayçal Zaouali

Editorial Coordinator
Paola Gallerani

Editing
Annie Van Assche

Translation of the entries and the biography
Susan Wise

Biography
Marco Campigli

The paper for this publication
has been kindly offered by:

ArjoWiggins

TABLE OF CONTENTS

'PERSONIFYING THE GOOD AND EVIL OF ALL HUMANITY'

Paul Joannides

Raphael used to say to me "Oh, how greatly it pleases me, M. Pietro, that Michelangelo is helping my new competitor by making drawings for him; for the verdict that his works do not stand comparison with mine will make it very clear to Michelangelo that it is not Sebastiano I outclass ... but rather him, who (and justifiably) regards himself as the [Platonic] Idea of draughtsmanship".

Raffaello mi soleva dire: "o quanto egli mi piace, M. Pietro, che Michel'Agnolo aiuti questo mio novello concorrente, facendogli di sua mano i disegni; percioche dalla fama che le sue Pitture non istiano al paragone delle mie, potrà avedersi molto bene Michel'Agnolo, ch'io non vico Bastiano... ma lui medesimo, che si reputa (e meritamente) la Idea del disegno".

The remark of Michelangelo's great rival Raphael, reported and published by Michelangelo's enemies, Pietro Aretino and Ludovico Dolce, finds a much more positive echo in a remark made by Jean-François Millet, one of the greatest draughtsmen of the nineteenth century, about a drawing in the Louvre. This is a study made by Michelangelo (Inv.716/pl.55) precisely for a painting by Sebastiano – although that fact was discovered only in the twentieth century: 'Mais, quand je vis le dessin de Michel-Ange qui représente un homme évanoui, ce fut bien autre chose: l'expression des muscles détendus, les méplats, les modelés de cette figure affaissée sous la souffrance physique, me donnèrent tout une série d'impressions; je me sentais comme lui supplicié par le mal. J'avais pitié de lui. Je souffrais de ce même corps, de ces mêmes members, Je vis bien que celui qui avait fait cela était capable, avec une seule figure, de personnifier le bien et le mal de l'humanité' (But when I saw the drawing by Michelangelo that represents a man in a swoon – that was another thing! The expression of the relaxed muscles, the planes and modelling of the figure weighed down by physical suffering, gave me a succession of feelings: I was tormented by pain, I pitied him, I suffered with that very body, those very limbs. I saw that he who had done this was capable, with a single figure, of personifying the good and evil of all humanity; A. Sensier, *La Vie et l'Œuvre de Jean-François Millet*, Paris, 1881).

It is significant that Millet focused upon a study of a single figure, for Michelangelo's art, even when it deals with many figures or figures in rapid action, reaches its greatest intensity when he deals with the isolated body. The precision and emotional profundity of Michelangelo's body-language, especially when treating the nude, is unequalled. Michelangelo can wring greater poignancy from the bending of a wrist, or the flexing of a muscle than any other artist.

In Dolce's dialogue, Aretino levelled an apparently powerful criticism against Michelangelo, remarking that when one has seen one of Michelangelo's figures, one has seen them all. But this is a sly perversion of the truth. Michelangelo's capacity for variety, even when constrained within strict limits, is unequalled. The twenty *Ignudi* who hold medallions and garlands on the Sistine Ceiling are all seated young nude males, but the variety – even in the earliest, less certain, figures – of pose, energy, character and spiritual state that they display has made them models, conscious or unconscious, for every later artist who has faced the problem of the seated nude. And when one considers that the *Ignudi* became more diverse and more energetic as work on the ceiling progressed, it becomes uncertain whether Michelangelo's imagination knew any bounds.

The master's capacity for visualising the same scene in a variety of different ways is equally remarkable. Thus the series of drawings dating from the early 1530s depicting Christ's Resurrection, made in at least three formats, probably with several different projects in mind, diverge radically in emphasis from one another. But in all of them the emotional pitch hardly finds an equal: in the Louvre's small sketch (Inv.691 bis/pl.54), Christ explodes from the tomb with the same ungovernable force with which God

the Father separates light from darkness on the vault of the Sistine; in another treatment of the subject in the British Museum (Corpus 258), Christ floats heavenward like vapour drawn upwards by the warmth of God's love; in a third, at Windsor (Corpus 265), of which there is a fine copy by Alessandro Allori in the Louvre (Inv.1505), Christ displays His Apollonine body as he greets the light after His forty hours in the tomb, His suffering entirely transcended.

A comparable instance of variety within an apparently narrow compass can be seen in the series drawings made by Michelangelo at the very end of his life, around 1562-3, of Christ on the Cross, with two mourning figures below (Inv.700/pl.60). Each one exploits a different dimension of emotion and spirit. Vittoria Colonna had written to Michelangelo some twenty years earlier about a drawing of the Crucifixion that Michelangelo had made for her (British Museum, Corpus 411; a good early copy of this drawing is in the Louvre, Inv.732) that it "crucified in her mind" every other version of the subject that she had seen; Michelangelo's late treatments of the subject have the same effect on many modern viewers. Their fusion of tragedy and transcendence, the way that the wavering contours inscribed by the aged draughtsman's shaking hand register the dissolution of the body and its transformation into spirit, the way the different stages and

concomitant possibilities of Christ's agony and death as a man are depicted, make these among the most profound of all treatments, both of the Crucifixion and its effect upon its witnesses.

The variety and range of Michelangelo's imagination and of his graphic execution can be demonstrated in another, entirely different, way. Over the past decade or so there have been four recoveries of drawings by Michelangelo recorded in the eighteenth century but subsequently lost to sight: the *Christ and the Samaritan Woman* formerly in the Bodmer Foundation, Geneva, and the *Stoning of St. Stephen* at the Chateau de Loppem, both once owned by Crozat, the *Rest on the Flight into Egypt* now in the J. Paul Getty Museum and the *Mourning Woman* recently found at Castle Howard. To these may be added, among others, the two pen drawings discovered in the Louvre in 1991 by Dominique Cordellier (Inv.12691/pl.8 and Inv.8026/pl.22 and 24), neither of which had previously been connected with Michelangelo. Each of these drawings illustrated a facet of Michelangelo's work different from those previously known: in composition, in subject matter or in handling. These new presences on the stage of Michelangelo's mind alert us to aspects of his activity which either remained under-appreciated or of which we were ignorant. Thus, from a technical point of view, the ex-Castle Howard drawing displayed a most painstakingly elaborate use of a pen much finer than Michelangelo is generally thought to have employed; the Getty drawing shows him mixing black and red chalk with brush and wash over stylus-work, a combination rarely seen in his other work; one of the two drawings discovered by Cordellier (Inv.8026/pl.22) displays a brutality of attack in its pen work, and a super-charged rapidity, that can hardly be parallelled in the early sixteenth century; while the other (Inv. 12691/pl.8), in its raw severe outline, demonstrates on a larger scale than elsewhere Michelangelo's capacity to generate plastic form by the use of stressed outline alone, a skill in which he surpasses even draughtsmen such as his contemporary Leonardo and his follower Rubens.

Furthermore, some of these discoveries have opened our eyes to a range of subjects and types of staging with which we were previously unfamiliar. The multi-figure *Martyrdom of St Stephen* at Loppem shows Michelangelo treating the same scene as Raphael in his Vatican tapestry, and producing a severe, angular meditation on public cruelty and the isolation of the martyr. The *Rest on the Flight into Egypt* shows Michelangelo transforming a theme much treated in Venice in an idyllic mode into a sombre vision both of Christ crucified and Christ risen. The ex-Castle Howard drawing demonstrates Michelangelo's ability to design drapery of a complexity that might have defeated even a Raphael. And, particularly relevant to collection of the Louvre, the highly detailed *modello* for the Candelabrum found only in 2002 in the Cooper-Hewitt, National Design Museum in New York by Sir Timothy Clifford, which displays Michelangelo's use of fine chalk lines, some of them ruled, supplemented by lightly applied wash, substantiates the authenticity of the Louvre's *modelli* (as carefully finished project drawings are nowadays generally called) for the tombs of Duke Giuliano and of the Magnifici in the New Sacristy of San Lorenzo (Inv.838/pl.42 and Inv.837/pl.41), two drawings much misunderstood by earlier scholars.

When we consider that Michelangelo destroyed vast numbers of his own drawings, and that there survive, from a working career of three-quarters of a century, around six hundred sheets of drawings, including

many of a purely routine nature such as block diagrams, it is evident that his graphic art remains an unexplored country, of whose expanse we shall never have more than a fractional idea. But it is also worth remarking that we can occasionally gain further insight both into Michelangelo's mind, and into his effect upon his immediate contemporaries in another way. Thus the rediscovery of the Castle Howard drawing demonstrated that it was known during Michelangelo's lifetime both to Francesco Salviati, who made a red chalk copy after it – now in the Louvre (Inv.2751) – and to Giulio Clovio, who adapted the figure as the mourning Virgin in a composition of the *Crucifixion* known in several versions. Few scholars would have been so perceptive as to attribute this figure design to Michelangelo in the absence of the original. Another, slightly different kind of example, is a little-known copy, in the Musée Fabre, Montpellier (Inv.864-2-195), of a lost study of the *Holy Family* by Michelangelo; this can be proved to have circulated, for a painting in a style reminiscent of Giovanni Battista Rosso, in an Italian private collection, is patently based upon this group. Expanding research among the followers and associates of Michelangelo will no doubt provide further *aperçus* of this nature, but we shall have to reconcile ourselves to the fact that our knowledge will always remain partial and distorted. Since we already know so much about Michelangelo, we tend to be slow to appreciate that, as far as his drawings are concerned, there is an infinite amount more that we shall never know.

The collection of drawings by Michelangelo in the Louvre is, in part, very well known. Some of the autograph drawings that it contains – a total of 43 in the present writer's count – are among the most studied of all Michelangelo's sheets. A sketch that was no doubt made during the process of preparation of the lost bronze *David* (Inv.714/pl.6), for example, is included in virtually every book on Michelangelo, both because of its liveliness and vitality, and because it provides evidence for a statue that has remained untraced since it was last recorded in an inventory in the 1790s. Similarly, the copy after two figures in Giotto's fresco in Santa Croce – where Michelangelo's own tomb is placed – of the *Elevation of St John the Evangelist*, generally considered one of Michelangelo's earliest surviving drawings – if not the earliest – is discussed by every scholar analysing Michelangelo's early work (Inv.706/pl.1). Some drawings have aroused an inordinate amount of controversy: the quantity of writing about a drawing such as the *Virgin and Child with St. Anne* (Inv.685/pl.27), which various scholars have attempted to divide among different hands and dates, would do credit to a whole team of medieval scholiasts; and the discussion of the study (Inv.720/pl.2) for the Magdalen in Michelangelo's early and unfinished panel of the *Entombment of Christ*, now in the National Gallery, London, has attracted a very great deal of – sometimes very negative – attention in recent years.

Other drawings, however, are relatively little known outside the pages of De Tolnay's great *Corpus dei Disegni di Michelangelo*. Thus the copy – discovered some forty years ago by Konrad Oberhuber – after Masaccio's Brancacci Chapel *Expulsion of Adam and Eve* (Inv.3897/pl.3), has received comparatively little attention from scholars, which is strange because it must be one of Michelangelo's earliest experiments with red chalk, and also because it bears on its verso a study for the *Battle of Cascina* (pl.3). This is of particular

interest, since it shows not only that parts of the scheme were intended to contain fast moving figures, but that it is likely that Michelangelo's initial conception even of the central group was much closer to a melée than the statuesque arrangement he finally adopted. Another little-noticed sheet in the Louvre helps clarify this process (Inv.713/pl.10). It contains a black chalk drawing for *Cascina*, a study for the torso of a male nude seen from the back, one that seems awkward and lumpy by comparison with the sublime study for the same figure in the Albertina (Corpus 53). But while not of great beauty, examination of it does help us to understand the way in which Michelangelo came to formulate the individual figures in his composition. The Louvre drawing shows a figure moving jerkily, probably directly confronting an enemy, the rhythms of his back suggestive of difficulty and uncertainty. In the Vienna study, made in the same medium on paper of the same size, Michelangelo adjusted the form, so it now rises in a confident curve as the figure stretches upwards not – it would seem – in order to fend off an opponent advancing towards him, but to strike downwards at an opponent in front of him. The movement is reduced, the demonstrative beauty of the back is emphasised, and from a naked soldier involved in an uncertain combat, Michelangelo has constructed a figure that, whatever his immediate circumstances, will certainly be victorious. The Louvre contains a drawing for another figure for *Cascina* (Inv.712/pl.9), of such sculpturesque beauty that Michelangelo later referred back to it when designing a statue probably intended for the *Julius Tomb* (known from a copy in the Louvre, Inv.694). Comparison of the first designs for *Cascina* with those figures finally decided upon for the central section of the scheme – known in a copy by Aristotile da Sangallo in Holkham

Hall – demonstrates that Michelangelo's vision of the battle modulated from a semi-realistic account of Florentine soldiers caught unawares by a surprise attack, to a scheme in which the reactions of the individual soldiers, when the trumpet of alarm is blown, become an image of those of the dead when the trumpets sound on the Last Day: their bodies demonstrate their moral and spiritual worth, their resolve and their readiness – *prontezza* – to face the final call.

The *Battle of Cascina* was perhaps the most significant of all Michelangelo's unexecuted pictorial projects for his immediate contemporaries, and the cartoon of the central section – which Michelangelo never began to paint – was considered by the sculptor and goldsmith, Benvenuto Cellini, to be the best thing that Michelangelo ever did; it became, for as long as it survived, the school of the world – a reputation amply demonstrated by the numerous copies made after figures in it, including several in the Louvre.

As these few examples may help to show, a systematic appraisal of the Louvre's collection of Michelangelo drawings – and of copies after lost drawings by him – opens insights into his work that can be obtained from no other collection, and this is in good part due to its provenance. What is sad, however, from the Louvre's perspective, is that this picture of Michelangelo's oeuvre so formed could have been very much more comprehensive.

It is well known that part of the collection of the banker, Everhard Jabach, was sold to Louis XIV in 1671 and that this, although it has been enormously expanded over the following three and a half centuries, forms the nucleus of the Louvre's collection of Italian and Northern European drawings. Jabach's

collection also provided some three-quarters of the Louvre's complement of Michelangelo drawings, not in every case knowingly: the two drawings discovered by Cordellier, for example, both came from Jabach but were not recognised as Michelangelo's in his inventory. Only a few drawings were added in the eighteenth century, when the Cabinet Royal failed to take advantage of the sale in 1741 of the fabulous collection of Pierre Crozat. This was a major loss in any terms, and it particularly affected the Louvre's holdings of Michelangelo drawings since Crozat is reported to have obtained from Jabach's heirs a large number of Michelangelo drawings that Jabach had also owned but had not sold to the Crown in 1671.

The main beneficiary of the Crown's oversight was Pierre-Jean Mariette, who catalogued the Crozat collection for the sale, and who himself bought very heavily. The neglect of the Cabinet Royal continued, and the posthumous sale of Mariette's own collection in 1775 brought only one additional Michelangelo drawing to the Louvre. The significance of this loss can be measured in part by the fact that the small but wonderfully choice collection of Michelangelo drawings in the Albertina all have a provenance from Mariette's collection and hence from that of Crozat. And since the Albertina's Michelangelo drawings are directly in series with some of those now in the Louvre, acquired from Jabach, it is likely that these too had been part of the magnificent runs of Michelangelo's owned by Jabach. The Louvre's loss was the Albertina's gain.

During the nineteenth century, the Louvre profited to a limited extent from the dispersal of the collection of Sir Thomas Lawrence during the 1830s, as much a missed opportunity for Britain as the dispersal of Crozat's collection was for France. Many of Lawrence's Michelangelo drawings were acquired by King William II of the Netherlands, and when his collection was sent for sale in 1850, after his death, the Louvre was able to acquire the study for the bronze *David* (Inv.714/pl.6-7), which had been owned by Mariette and the study for the Ubeda *Pietà* (Inv.716/pl.55) so much admired by Millet, a drawing that had been in the collection of Michelangelo's collateral descendants in the Casa Buonarroti, until the depredation of their holdings in the 1790s. Subsequently, the Louvre acquired, from Edouard Gatteaux in 1881, one of the most beautiful of all Michelangelo's pen studies of the male nude (Inv.RF1068/pl.16-17), a drawing that had also once been owned by Mariette and, probably, Crozat and Jabach; and a further damaged but fascinating drawing, recorded in the Casa Buonarroti in the early seventeenth century but which had mysteriously left that collection by the mid-eighteenth, was presented by the great portraitist, Léon Bonnat, in 1912 (Inv.RF.4112/pl.28-29).

But whereas the record of acquisitions of Michelangelo drawings by the Louvre contains missed opportunities, that is true of all historical collections. What is more important here is to assess the significance of what the collection does contain. It seems to be the case that most – although not all – of Jabach's acquisitions of drawings by Michelangelo were made within France, and this is an observation of great interest, for it suggests strongly that the majority of his Michelangelo drawings came from a group that has the strongest possible claim to authenticity, and a provenance from the earliest known collection of Michelangelo drawings.

In 1523 Michelangelo took on a new apprentice. Antonio Mini seems to have been a loyal servant of his master, and was much appreciated by him. He may also have served as Michelangelo's model. Mini's

intelligence and ability had strict limitations, and he seems never to have attained more than a basic competence as an artist; some of his earliest efforts at draughtsmanship are so feeble that it is surprising that they have survived at all. But from such drawings it can be seen that, as well as prescribing specific drawing lessons for his pupil, whom he occasionally taught together with one or another of the young amateurs that he encouraged, Michelangelo also gave his pupil some of his own earlier drawings to copy. Among these, for example, was probably a study of c.1503 for an Apostle, planned for the Duomo commission of that year, that Mini recorded at some time in the 1520s (Inv.855). In another instance, Michelangelo set his pupil to copy one of his presentation drawings of an ideal female head (the original is now lost). Either exasperated by Mini's efforts or, in an impromptu *jeu d'esprit*, Michelangelo covered Mini's copy, which is in red chalk – with a vigorous pen drawing of a head which is the very opposite of ideal: that of an ugly – but vital – *Faun* (Inv.684/pl.44). In another instance, in a drawing now in the Ashmolean (Corpus 96), Michelangelo submerged some chalk sketches of profiles made by Mini with a magnificently sinister drawing of a large ferocious dragon, made in pen. The provenance of the Ashmolean drawing, incidentally, can be traced back no further than to Dominique Vivant-Denon, but it too may have come to France with Mini. It was copied in a drawing – probably made within the sixteenth century – now in the Louvre (Inv.693). Such lively interchanges between pupil and master reflect, in reverse – an incident of Michelangelo's youth recorded by Vasari, in which the young man corrected a drawing by his own master, Ghirlandaio. Like Raphael, Michelangelo was frequently stimulated by engagement with the work of

others, and even the drawings of a relatively incompetent pupil such as Mini could engage him, much as a Picasso might take an interest in the drawing of a child.

Early in 1532, Antonio Mini decided to seek his fortune in France. Michelangelo had himself considered entering the service of François Ier in 1529, when he briefly fled Florence during the siege of the city by the Imperial armies, but in the event he returned to his post. This aborted plan perhaps encouraged Mini, who no doubt hoped that the great enterprise of Fontainebleau would offer him – as it did Rosso – opportunities unattainable in Italy. According to Vasari, Michelangelo, in addition to the large panel painting of *Leda and the Swan*, executed for Alfonso d'Este but not in the event delivered to him, presented his pupil with two cases of cartoons, drawings and models. It is anyone's guess how many sheets of drawings were included, but they may well have numbered in the hundreds. And it is certain that as well as work executed by Michelangelo in the 1520s, including sheets on which Mini too had worked, the gift contained drawings by Michelangelo made over at least three decades and probably four. There is a fair likelihood – although it cannot be taken as axiomatic – that any drawing by Michelangelo datable before c. 1530, which either remains in a French collection or whose known provenance starts in France (such as the group of drawings in the Albertina), originates in Michelangelo's gift to Mini.

Mini was very unfortunate. He soon seems to have lost control of the *Leda*, although not before he had made several copies of it for sale, and he had no success at the court of François Ier. He did not long survive this disappointment and the last recorded letter from him is of 1533. He probably died in 1534. Soon after 1540, Michelangelo succeeded in recovering at

least some of the cartoons that he had given to Mini – and which he himself no doubt later destroyed – but it is clear that large numbers of his drawings and models remained in France. Of the models, no sure trace now remains, although it is not unlikely that echoes of them are heard in work produced in France in the mid- and later sixteenth century, in particular in the sculpture of Jean Goujon and Germain Pilon: it would not be hard to see the latter's *Risen Christ* in the Louvre as indebted to Michelangelo's ideas. But what is quite clear is that a number of Michelangelo's drawings were known to, and no doubt owned by, Francesco Primaticcio, who included in several of his own drawings precise quotations from sheets by Michelangelo, sometimes the same size as the originals.

While the number of drawings by Michelangelo owned by Primaticcio is conjectural, it is likely that it far outstripped those he can be proved to have known and used. The fate of Primaticcio's collection of drawings after his death in 1570 cannot yet be traced, but it is probable that most of it remained in the possession of his heirs (unlike Charles Lebrun's and Pierre Mignard's drawings a century later, Primaticcio's did not become the property of the crown) and in his atelier until they were acquired early in the seventeenth century by the collectors Denoux and Delanoue – whose identities have only very recently been clarified. From these collectors, the drawings – or many of them – were subsequently acquired by Jabach. Jabach of course bought drawings by Michelangelo from other sources: the Louvre's great *Crucifixion* (Inv.700/pl.60) was owned by him, and this was executed some thirty years after Mini's death. And the study for the Sistine Ceiling (Inv.860/pl.30-31) seems to have been in Casa Buonarroti in the 1580s and probably escaped from that collection only in the seventeenth century.

But with these and a few other exceptions, it is likely that the majority of drawings owned by Jabach came from the group owned by Mini, and that this was assembled by Michelangelo with the aim of providing for his pupil a wide range of his own manners and a wide range of different types of drawings.

It is not possible to calculate the full extent of Jabach's holdings of drawings by Michelangelo, since the inventory of his "second collection" – which included many drawings that he had withheld from sale to the crown in 1671 – either deliberately conceals what he owned or compels one to assume that they were sold by Jabach before his death. But when the Jabach Michelangelos that are now in the Louvre are added to those drawings which seem to be in series with them, among which many passed through Crozat's collection, it might be conjectured that Jabach owned at least one hundred autograph drawings by Michelangelo and perhaps many more. Sir Thomas Lawrence was later to own a larger number, but his collection included many slight and scrappy drawings whose interest and beauty, although great, hardly compares with that of the generally more finished drawings owned by Jabach. It is worth emphasising that Jabach's group would have consisted largely of drawings selected for Antonio Mini by the artist who knew Michelangelo's drawings more intimately than any other, Michelangelo himself. And Michelangelo, conscious that his pupil possessed nothing of his own creative abilities, no doubt gave Mini drawings that would have been of practical use to him. One obvious category would have been finished studies for figures that could be inserted into Mini's own pictorial compositions. In other cases, a single figure might even comprise a composition: a drawing such as the *Male Nude* (Inv RF.1068/pl.16) could serve as a Saint

Sebastian; one such as the "Mercury" (Inv.688/pl.21) could find his place as an Apollo in a composition at Fontainebleau. An apparently slight but fully worked out figure drawing would also be useful: the kneeling Magdalen (Inv. 726/pl.2) could readily be inserted into an altarpiece, a figure such as the Faun (Inv.697/pl.35) could as easily be inserted in a genre scene of dance as an antique bacchanal. Studies of the Virgin and Child, that staple of artistic production in the period, and the subject of one of the earliest exercises that Michelangelo had set to Mini, as a sheet of studies now in the British Museum demonstrates (Corpus 240), would be of clear use, and some of the mother and child groups that Michelangelo made around 1530 might even have been made with his pupil specifically in mind (Inv.692/pl.47-48, Inv.691/pl.50).

Another category of drawing that Michelangelo would have provided for Mini was studies for sculptural ensembles. It is doubtful whether Mini ever nurtured ambitions as a pure architect and it seems unlikely; perhaps as a consequence, no purely architectural drawings by Michelangelo can be traced through French collections in the sixteenth and seventeenth centuries. However, studies for sculptural-architectural ensembles were another matter, for these would also be helpful to an artist planning ephemeral structures for festive or triumphal occasions, or decorative work in stucco, a centrally important feature at Fontainebleau. The black chalk study for the Magnifici Tomb (Inv. 686/pl.39) was certainly among the drawings that Michelangelo gave to Mini, since the figure on the recto of the same sheet was employed by Primaticcio in a group of the Banquet of the Gods planned for a fresco at Fontainebleau. And it also seems that the two modelli for the New Sacristy

tombs (Inv.837/pl.41 and Inv.838/pl.42) were also part of Michelangelo's gift. By the time Mini left for France both tombs had been simplified or re-designed and these designs superseded. Reinforcing the likelihood that these drawings were given to Mini, is the history of another drawing of similar type, but made a few years before the New Sacristy project drawings, Michelangelo's modello for the base of the Julius Tomb (Corpus 56). Although now in the Uffizi, this drawing was only acquired for that collection in 1775 at the sale of Pierre-Jean Mariette, whose mark it bears. It too had probably been given to Mini.

Most of Michelangelo's sculptural-achitectural modelli remain in Casa Buonarroti as do the great majority of his architectural drawings. Few drawings of this type left Italy before the dispersals of the 1790s, and with few exceptions they have rarely proved attractive to collectors and scholars. The Uffizi drawing, for example, is still rejected as autograph by many scholars despite the fact that it bears varied underdrawings in black chalk, and despite the fact that its verso carries a series of red chalk studies of hands that are among the most beautiful that Michelangelo ever made. It is a strange paradox of art history that it is only in recent years that the great runs of drawings of this type in the Casa Buonarroti itself, the fountain-head of authentic work by Michelangelo, have been revalued, and that scholars have overcome a reluctance (prejudice?) to accept that Michelangelo ever made precisely measured drawings or ever employed a ruler. But when blinkers are removed and when Michelangelo's highly finished drawings for architectural-sculptural ensembles are compared with those by his friends and contemporaries such as Giuliano da Sangallo and Antonio da Sangallo the Younger, it can be seen that they display

an awareness of texture, volume and fall of light, as well as a precision and delicacy of handling, that far outstrip the drawings of these professional architects.

A further class of drawing in which the Louvre's collection is particularly rich seems at first sight unlikely for Michelangelo: this might be described as the "soft" study. Drawings of this type, in which the use of black chalk in the first decade of the sixteenth century gradually gives way to the red that dominates in the third, have frequently caused disquiet among purist scholars and their role in Michelangelo's creative procedure has never been properly understood. It seems, as can be seen from drawings made both for the *Battle of Cascina* (such as Inv.726/pl.4) and for the Sistine Ceiling (Inv.860/pl.30), that having made initial compositional and figural sketches, Michelangelo chose to lay in figures with a soft chalk or with the side of the chalk, rather than the point – sometimes over a thin scaffolding of metal-point indentation. It is likely that this practice was not uncommon, but most drawings of this type would have been made in friable charcoal, easily smudged, and would consequently have been discarded. From Michelangelo, who placed such emphasis on sculpturesque relief and strong and severe modelling, such pulpy drawings might seem uncharacteristic, but in establishing the broad massing of the forms, Michelangelo provided himself with a firm foundation for the more detailed work of modelling, whether this was carried out with pen – as it mostly was in his early years – or chalk, which Michelangelo generally used thereafter. It was vitally important for Michelangelo to understand the broad mass of the figure that he planned to develop. In order to communicate that intensity and poignancy that are so central to Michelangelo's art, modelling had to be selective and elastic, reducing emphasis in one area of the body in order to concentrate it in another. Unlike Baccio Bandinelli, for example, whose technically masterly drawings display an overall evenness of emphasis that rarely succeeds in conveying emotion, Michelangelo's drawings in all media are geared primarily to affect. First establishing the generality – the base melody, as it were – Michelangelo was then able to amplify or dimish local phrasing.

This type of "soft" drawing began life as a merely functional device and those examples that have survived from Michelangelo's early period have done so largely because they are found on the versos of more attractive sheets. But during the course of Michelangelo's work on the Sistine Ceiling, he increasingly became conscious of the aesthetic and emotional effect of simplified masses and broader volumes, a development that can readily be charted by comparing the earlier *ignudi* with the later ones. A comparable progress can be seen, a little later, in sculpture, if Michelangelo's *Slaves* in the Louvre are contrasted with those in the Accademia in Florence.

The Louvre's group of red chalk drawings made in the 1520s and early 1530s demonstrate this process in a remarkable way. Thus the study for *Sibyl* or *Virgin and Child* (Inv.704/pl.53) is not a particularly attractive drawing and it has sometimes been rejected. It establishes the forms broadly and simply for a static group; the complex study for an *Entombment* or *Deposition* on the verso shows this method applied to a scene of action. On both sides, Michelangelo has established clear parameters for further work. In another case, however, the *Wrestlers* (Inv.709/pl.45), although the forms are soft and although the repeated contours are not fully resolved, the drawing is not simply a stage towards something more precise but appears complete in itself, conveying an effect of ele-

mental mutability and struggle. A type of drawing produced to play a specific role in a determined sequence has gradually come to assert its own self-standing aesthetic vitality. And it leads also in a new direction, for while the execution of such a drawing as the *Wrestlers* could hardly be more beautiful, its physical appearance diverges from the type of beauty that Michelangelo's contemporaries – to say nothing of modern scholars – might have expected.

Indeed once this type of generalised mode had begun to declare independence, it became the foundation for the next major stage of Michelangelo's art, that which is represented by the *Last Judgement*. At this time, in his mid-50s, Michelangelo began the long march away from the ideal of human beauty that had dominated his work hitherto, in search of a style purified from sensuality. In the *Last Judgement*, forms are generalised and inflated beyond any human possibility and although bodies are powerfully modelled, they are modelled without sensuousness, and local effects of pathos – individualism – are eschewed in the interests of continuity.

In Michelangelo's last frescoes, in the Pauline Chapel, in which nudity is reduced and the draped figure predominates, and in the religious compositions that he designed for others during the last two decades of his life (such as Inv.720/pl.56-57) and its companion (Inv.698/pl.58), it is breadth and smoothness that reign. The manner of drawings such as Michelangelo's study (Inv.704/pl.53), in which smooth planes of drapery are not designed to register the body beneath, and are articulated with long running forms and ridges, became the founding manner of his late style. Other examples of this type of drawing, made around 1530, were probably brought to France by Mini but no longer remain there. Among these are the

Pietàs now in the Albertina and the Ashmolean (Corpus 269, 432, 431), all of which have French provenances. In presenting such drawings to his young friend, Michelangelo was merely providing him with instruments for his work. He himself may not yet have been fully conscious of the value of the principles adumbrated in his "soft" drawings of around 1530. These were not taken up by Italian artists for at least twenty years, and while Primaticcio and his French followers made use of figures from both sides of Inv.704/pl.52-53, it was simply as forms that they exploited them, entirely ignoring their style.

Even from this brief glance, it is evident that the Louvre's collection has major gaps and that it cannot aspire to the comprehensiveness of the collections of the British Museum or the Ashmolean Museum, both of which benefited very extensively from the dispersals from Casa Buonarroti. Nor can it match the collections of Michelangelo's native city, Florence, which, when the works that remain in Casa Buonarroti are added to those in the Uffizi, some of them owned by Florence's first Duke, Cosimo I, possess the longest run anywhere of drawings by Michelangelo. The Louvre has no serious representation of Michelangelo's architectural drawings – although there is a very important one in Lille (Corpus 595) – nor does it possess any of the ultra-refined presentation drawings made by Michelangelo for his friends, that form one of the glories of the British Royal Collection.

In compensation however, it can boast the residue of a group of drawings whose selection, for those antedating 1532 – is due to Michelangelo himself. It contains an unequalled series of pen studies of the male nude dating from the first decade of the *Cinquecento*, when his handling of pen reached a pitch of precision,

a combination of delicacy and sculptural strength – that have made these drawings the unequalled model for all anatomical pen drawings than have followed them. And in no other collection can be found so fascinating a range of drawings both in black and in red chalk, dating from the 1520s, some of them by no means immediately attractive but of great draughtsmanly inventiveness. Finally, the master's late drawings, and especially the sublime *Crucifixion* (Inv.700/pl.60) which is probably the masterpiece of the series, the Louvre possesses one of the most profound examples of spiritual meditation in Christian art.

Chronology

March 6th, 1475
Born Michelangelo at Caprese, near Arezzo, to Ludovico Buonarroti and Francesca del Sera. Father is governor (*podestà*) of Chiusi and Caprese. At the end of his father's mandate and soon after his birth, Michelangelo returns to Florence with his family.

1487
Documented presence of Michelangelo in the workshop of the Ghirlandaio brothers, Domenico and Davide.

Circa 1489 – 1490
He is a frequent visitor in the Giardini di San Marco where Lorenzo il Magnifico's classical sculpture collections were assembled.

1490-1492
Lives in the Palazzo Medici on via Larga. The *Madonna on the Steps* and the *Battle of the Lapithae and the Centaurs*. (Two marble reliefs presently in Casa Buonarroti are probably from this period.)

1492-1493
At the death of il Magnifico, leaves the Palazzo Medici. During these years, he carves the marble, *Hercules*, perhaps for Piero di Lorenzo de' Medici, oldest son of il Magnifico (lost), and the wooden *Crucifix* for the prior of the convent of Santo Spirito (now back in its original location).

1494
In October, leaves Florence; spends a few days in Venice and then settles in Bologna.
Completes the work by Niccolò dell'Arca in the basilica of San Domenico.

Late 1495 – early 1496
Returns to Florence, a guest of Lorenzo di Pierfrancesco de' Medici. Succeeds in selling to Cardinal Raffaele Riario the *Sleeping Cupid*, passing it off as a classical sculpture. When Riario discovers the deception, he demands his money back but insists on Michelangelo joining him in Rome.

1496
On June 25th, Michelangelo reaches Rome and takes up residence at the home of the banker, Jacopo Galli. Cardinal Riario commissions him for the marble, *Bacchus* (now in Florence, Bargello Museum).

1497
For Jacopo Galli, he sculpts his *Apollo* (now identified as the one in the Payne Whitney House in New York). Receives an advance for the *Pietà* (Rome, San Pietro), commissioned of him by Cardinal Jean de Bilhères de Lagraulas. Between the end of the year and the beginning of the next, he is at Carrara to purchase the required marble.

1498
In August, the contract is drawn up for the *Pietà*, which would probably be completed the following year.

1500
Michelangelo reaches an agreement with the friars of Sant'Agostino to paint a panel (perhaps to be identified with the unfinished *Entombment* now in London, National Gallery).

1501
Returns to Florence, possibly by March. On May 22nd, signs a contract with Cardinal Francesco Todeschini Piccolomini (future Pope Pius III) to carve fifteen statues for the Piccolomini altar in the Siena Duomo.

(Michelangelo will only execute those of Saints Peter, Paul, Pius and Gregory).

On August 16th, is given a huge block of marble, stored at length in the storerooms of the Opera del Duomo, to cut the figure of *David*. Work begins on September 13th.

1503 Is engaged to carve the statues of the twelve Apostles for the Florence Duomo (the unfinished Saint Matthew, now in Florence, Accademia, is all that survives).
Toward the end of the year, receives payment from the Flemish merchant Alexandre Mouscron for a statue of the *Madonna with Child* (Bruges, Notre Dame).

1504 As soon as the *David* is completed, it is placed in front of the Palazzo della Signoria in Florence.
In August he is called upon to paint the fresco of the *Battle of Cascina* for the Sala del Gran Consiglio in the Palazzo della Signoria; he does only the preparatory sketches and the cartoon (presently destroyed).
Two marble reliefs representing the *Madonna with Child and the infant Saint John*, (the 'Taddei Tondo', now in London, Royal Academy, and the 'Pitti Tondo', now in Florence, Bargello), and the painted panel with the *Holy Family* (known as the 'Doni Tondo', now in Florence, Uffizi) belong to this period.

1505 In March, is called back to Rome by Pope Julius II to carve his mausoleum. Once the design is approved, Michelangelo is at Carrara from May to December to choose the marbles.

1506 On his return to Rome early in the year, the Pope refuses to see him. Michelangelo leaves the city for Florence. On the insistence of the Pope, they are reconciled in Bologna on November 21st. The Pope asks him to execute a bronze statue in his likeness to be placed on the façade of San Petronio.

1507 In July, the statue of the Pope is cast; it will be destroyed four years later.

1508 In April, Michelangelo is in Rome. On May 10th, he is engaged to fresco the vaulted ceiling of the Cappella Sistina.

1512 On October 11th, he completes his work in the Cappella Sistina.

1513 Julius II dies. Michelangelo comes to an agreement with his heirs to create a new design for his tomb, of smaller dimensions; in view of it he sculpts the *Moses* (Rome, San Pietro in Vincoli) and two *Slaves* (now in Paris, Louvre).

1516 He finishes his new design for the Tomb of Julius II, of which remain the unfinished statues of four *Slaves* (now in Florence, Accademia) and *Victory* (now in Florence, Palazzo della Signoria), carved between 1516 and 1530.

1516 – 1517
Travels frequently to Carrara for the marbles of Julius II's monumental tomb. The new Pope, Leo X, son of Lorenzo Il Magnifico, commissions him for the façade of the church of San Lorenzo in Florence (never executed).

1520 Completes first designs for the Sagrestia Nuova of San Lorenzo, intended to receive the tombs of Lorenzo il

Magnifico, Duke of Urbino, and his brother Giuliano, Duke of Nemours.

1521 From Florence he sends the marble statue, *Risen Christ*, intended for the Roman church of Santa Maria sopra Minerva.

1524 The new Pope Clement VII de' Medici exhorts him to resume work—broken off in the meantime—in the Sagrestia Nuova. The pope furthermore asks him to design a Library for the same San Lorenzo complex.
I recommend rewriting entry to read:
The new Pope Clement VII de'Medici exhorts him to resume work – taking him away form his work on the Sagrestia Nuova–and instead asks him to design a Library for the same San Lorenzo complex.

1527 The Sack of Rome; the Medicis are once again expelled from Florence. Michelangelo interrupts the work at San Lorenzo and joins the Republican government.

1529 Engages in redesigning the city's defensive system. Fearful of the political situation in the city, in September he leaves Florence to go to France. He stops in Venice and by November is back in Florence.

1530 The Florentine Republic falls and the city is once again controlled by the Medici family. Clement VII forgives him immediately, exhorting him to resume work on San Lorenzo.

1532 – 1534 Divides his time between Florence and Rome. Clement VIII commissions him to paint the fresco of the *Last Judgement* in the Cappella Sistina.

1534 In September, he settles permanently in Rome.

1535 Pope Paul III confirms the commission for him to fresco the *Last Judgement* on the altar-wall of the Cappella Sistina; he is also appointed "supremo architetto, pittore e scultore dei Palazzi apostolici".

1536 – 1538 Begins to study the new layout of the Piazza del Campidoglio.

1541 Unveiling of the Cappella Sistina's *Judgement*.

1542 Thanks to the Pope's intercession, an agreement is reached for Julius II's tomb: the heirs are to rest content with the statues Michelangelo has already executed and are willing to have other artists complete the work. He begins the frescoes in the Cappella Paolina in the Vatican.

1545 Completes the *Conversion of St. Paul* in the Cappella Paolina.

1546 Antonio da Sangallo the Younger dies. Michelangelo is appointed architect for the fabric of San Pietro and for the completion of the Palazzo Farnese. He starts to plan the design for the staircase of the Ricetto of the Biblioteca Laurenziana in Florence.

1550 Completes the *Crucifixion of St. Peter* in the Cappella Paolina. Begins work on the marble *Pietà* (unfinished; now in Florence, Museum of the Opera del Duomo).

1555 – 1559 Devotes himself to architectural designs for the dome of San Pietro and the Roman church of San Giovanni dei Fiorentini. Begins the *Rondanini Pietà* (also remains unfinished; now in Milan, Castello Sforzesco).

1561 – 1563 Works on additional architecture designs for Porta Pia, the church of Santa Maria degli Angeli, and the Cappella Sforza in Santa Maria Maggiore.

February 18th, 1564 Michelangelo dies in Rome. He is buried with great pomp in Florence.

Plates

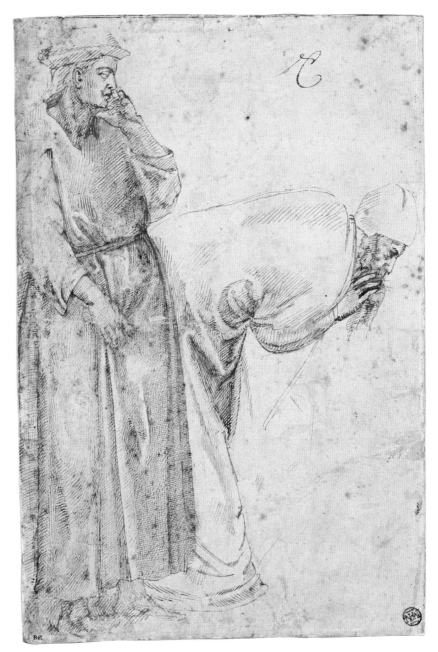

1. *The Ascension of the Evangelist, copy after Giotto*

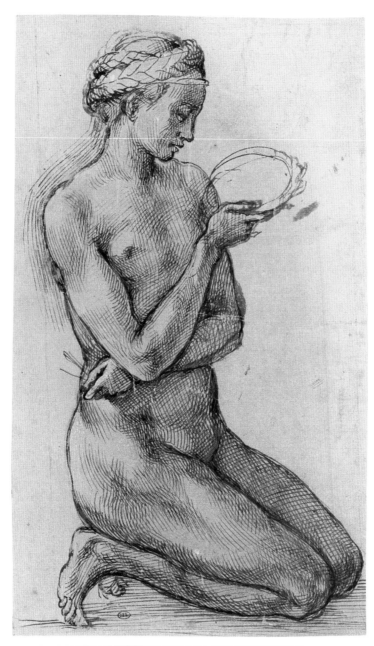

2. *Mary-Magdalene (?) gazing at the Crown of Thorns*

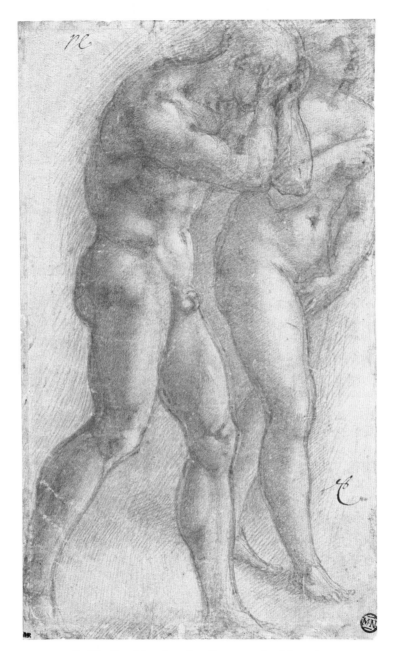

3. *The Expulsion from Paradise, copy after Masaccio*

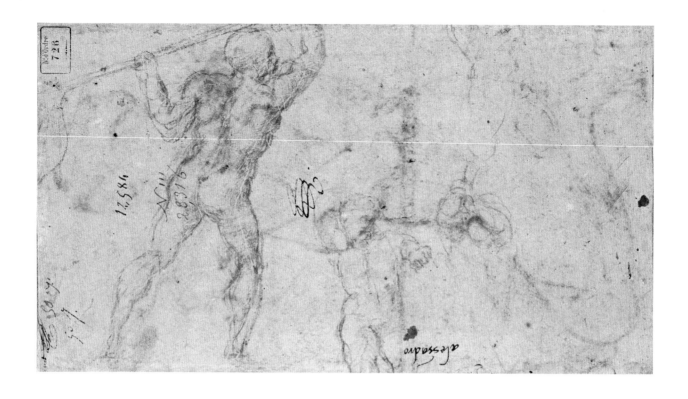

4. *Studies of figures, several for the Battle of Cascina*

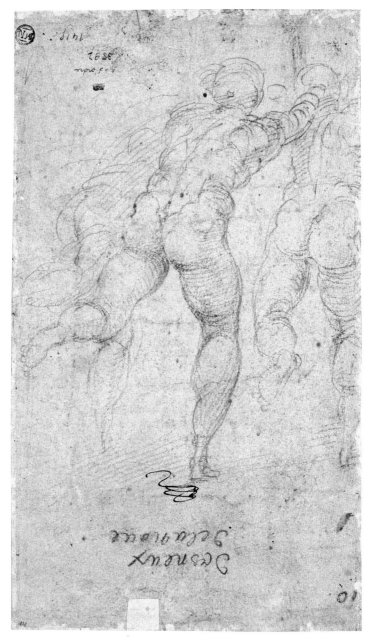

5. *Three figures running, for the Battle of Cascina*

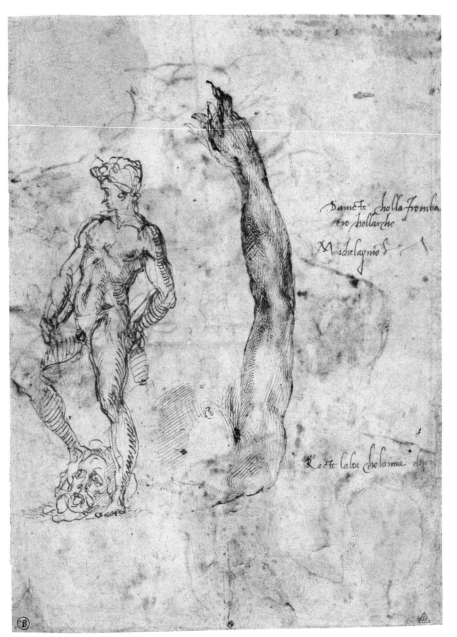

6. *Sketch for the bronze David and other studies*

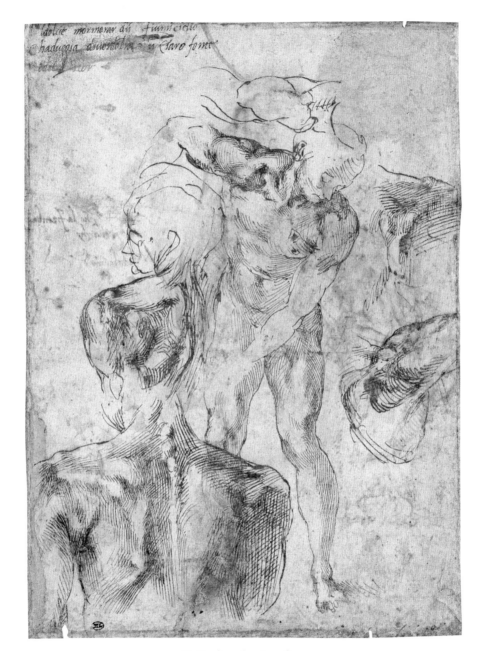

7. *Studies of various figures*

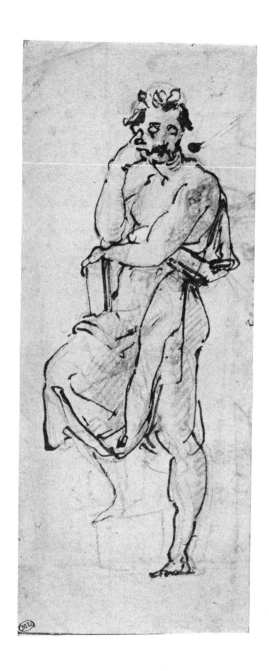

8. *Saint John the Evangelist*

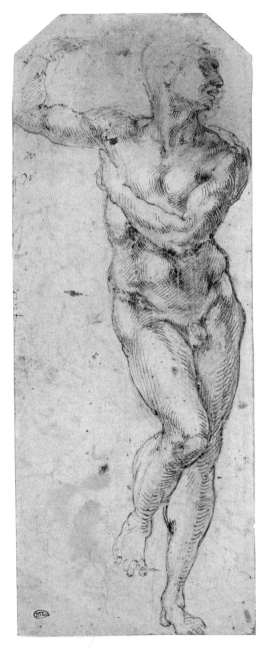

9. *Figure for the Battle of Cascina*

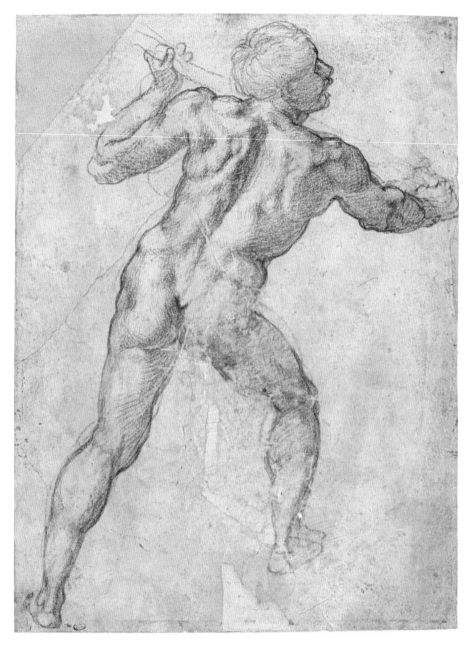

10. *Study of a figure for the Battle of Cascina*

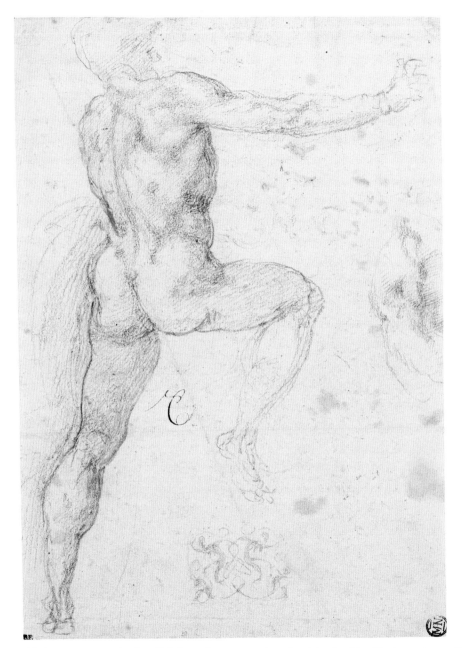

11. *Nude man, in profile; detail of frontal representation of a right shoulder (?) decorative motif*

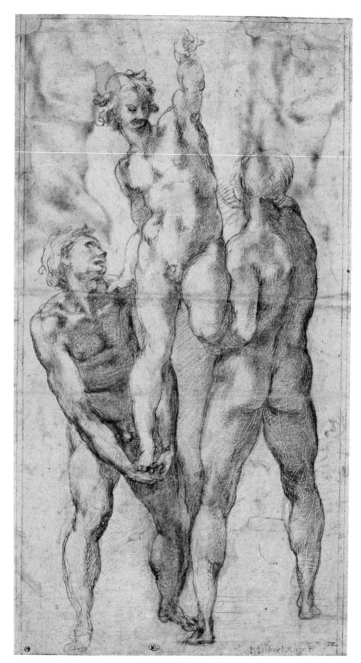

12. *Two male nudes raising a third male nude*

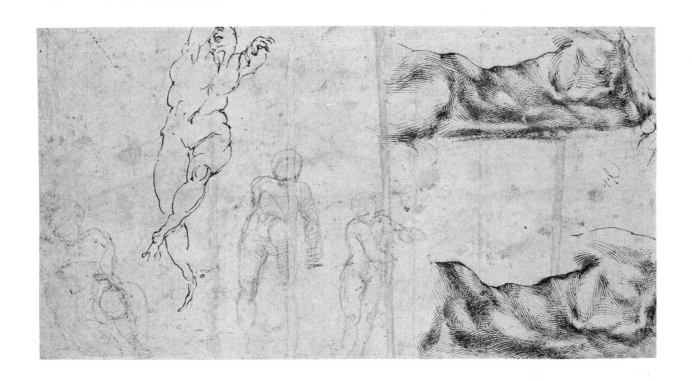

13. *Six studies of figures: two drawn vertically (in the same direction as the recto), four drawn horizontally*

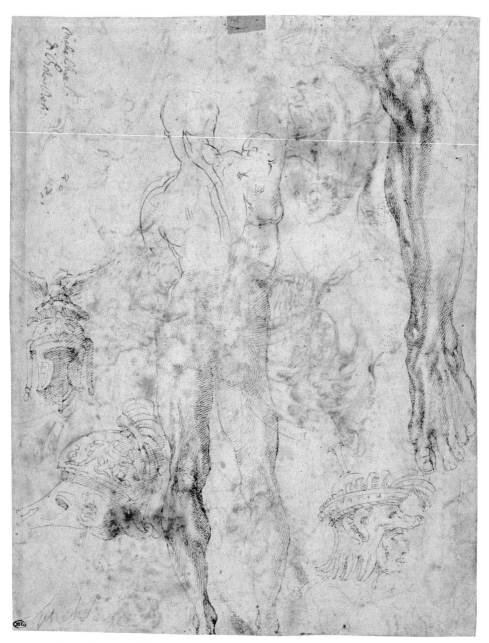

14. *Male nude seen from behind and other studies*

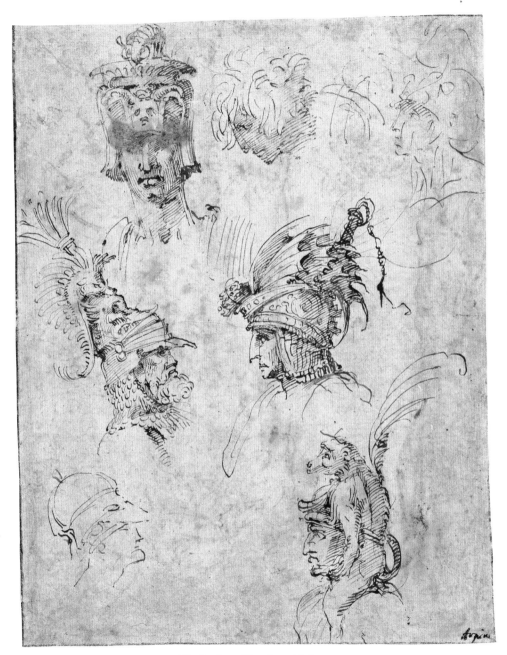

15. *Studies of heads and helmets*

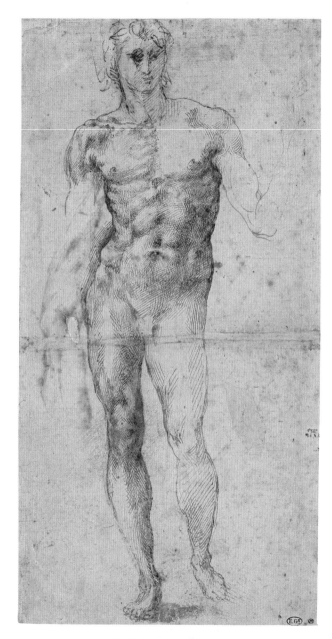

16. *Full-frontal male nude.*

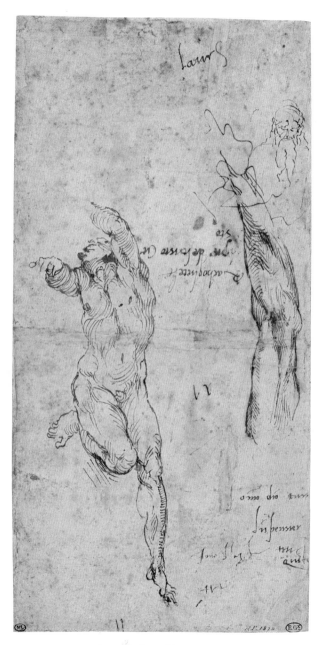

17. *Various studies of figures; inscriptions*

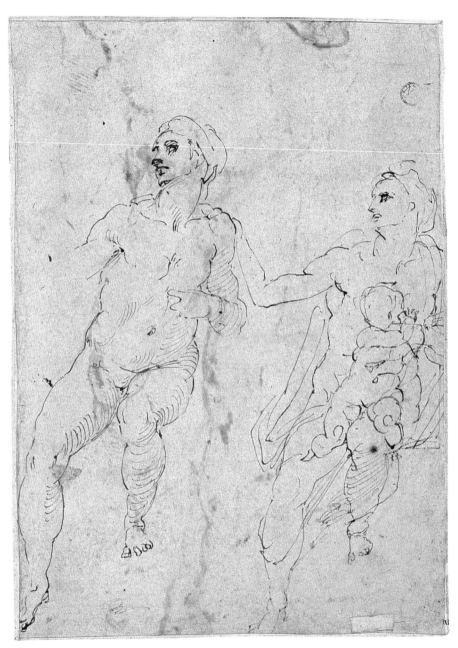

18. *Two studies of seated figures, one holding a child*

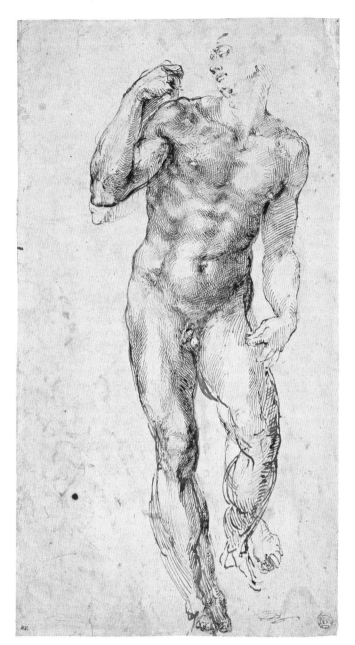

19. *Male nude, frontal view*

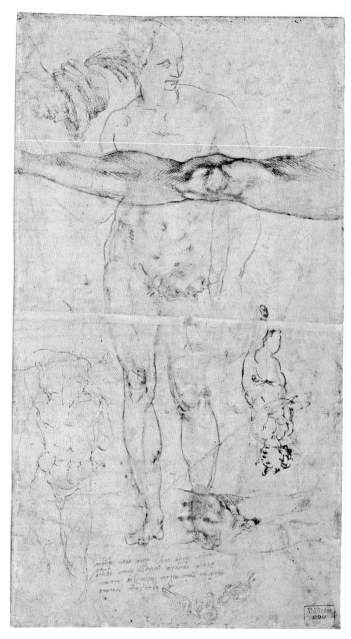

20. *Various studies of figures; inscription after a sonnet by Petrarch*

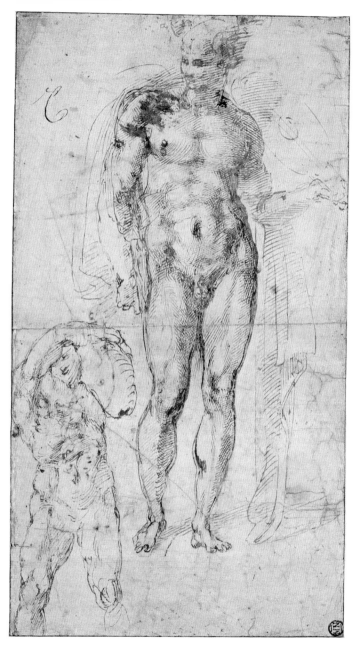

21. *Frontal view of male nude (Mercury/Apollo); man carrying a burden*

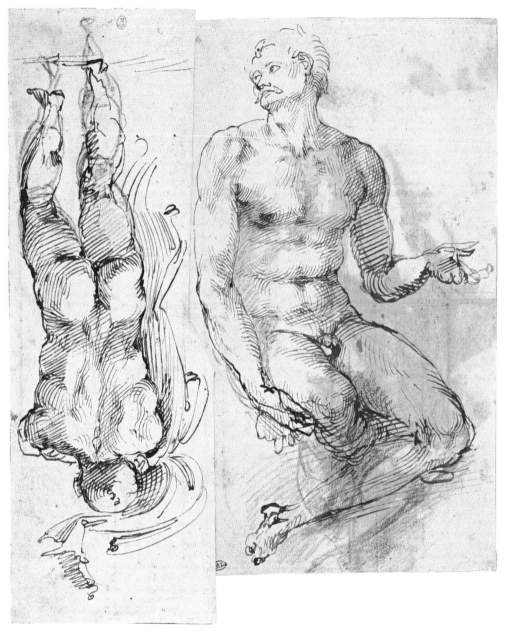

22. *Male nude seen from behind* **23.** *Study for a seated prophet*

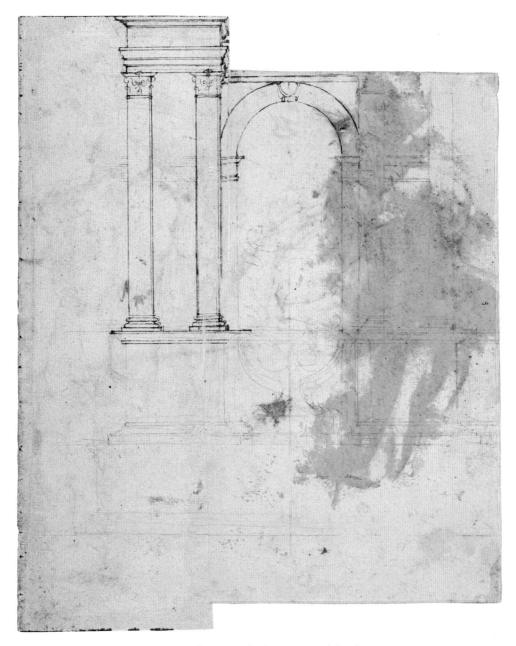

24-25. *The Tomb of Julius II, part of the elevation*

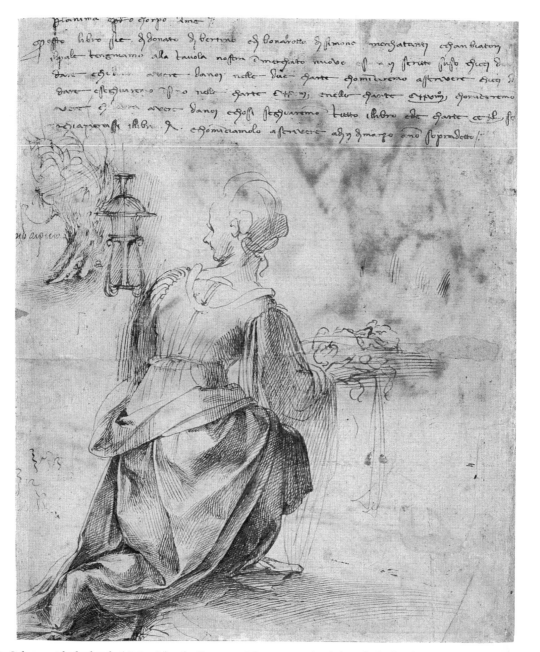

26. *Salome with the head of Saint John the Baptist* or *The servant of Judith with the head of Holofernes; inscriptions*

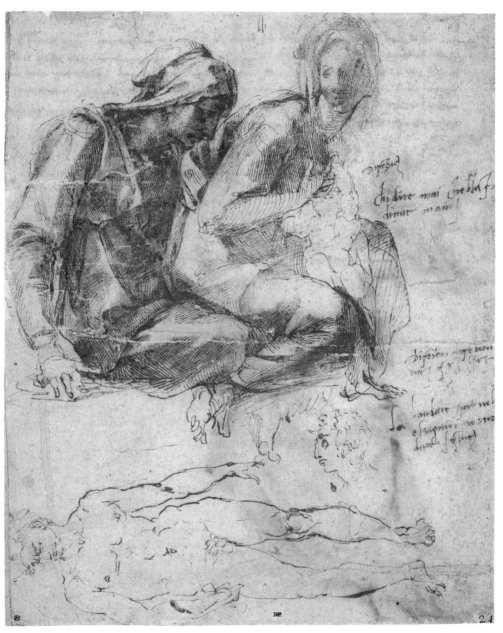

27. *The Virgin and Child with Saint Anne; a male nude; inscriptions after a sonnet by Petrarch*

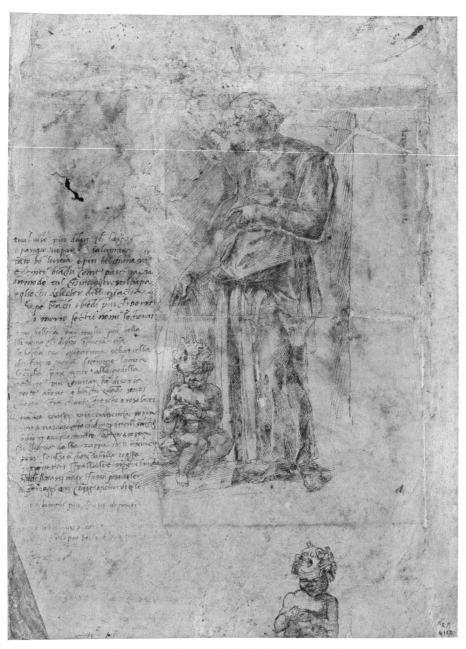

28. *The Virgin standing with the Child and Saint John; poem*

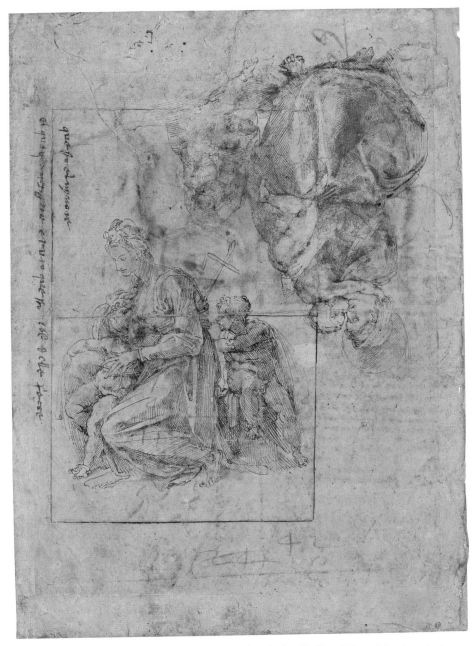

29. *Two compositions showing the Virgin seated with the Child and Saint John; inscriptions*

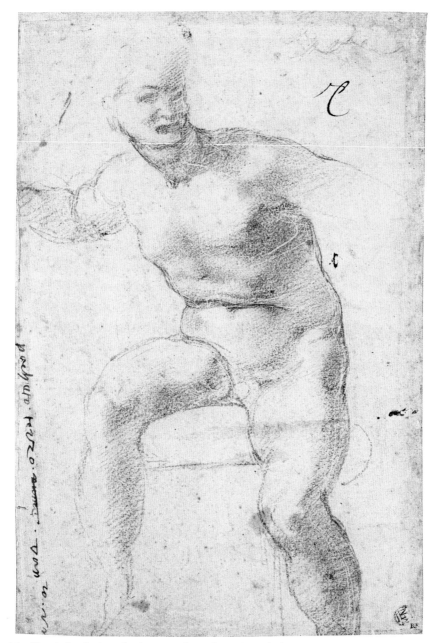

30. *Sketch for the Ignudo above Isaiah; outline of a right hand and forearm; inscriptions*

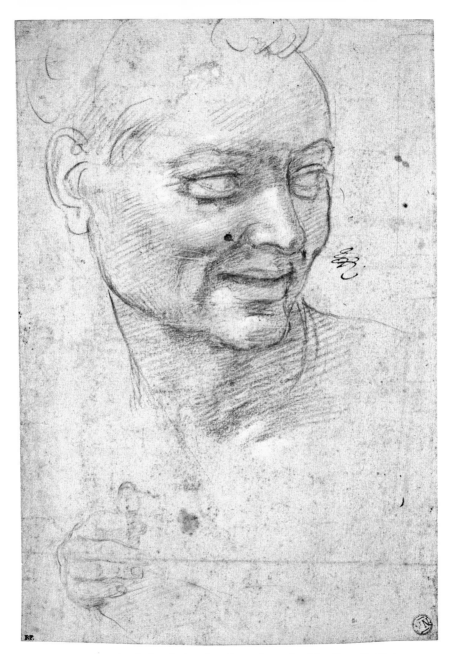

31. *Head and right hand of an Ignudo on the vault of the Cappella Sistina*

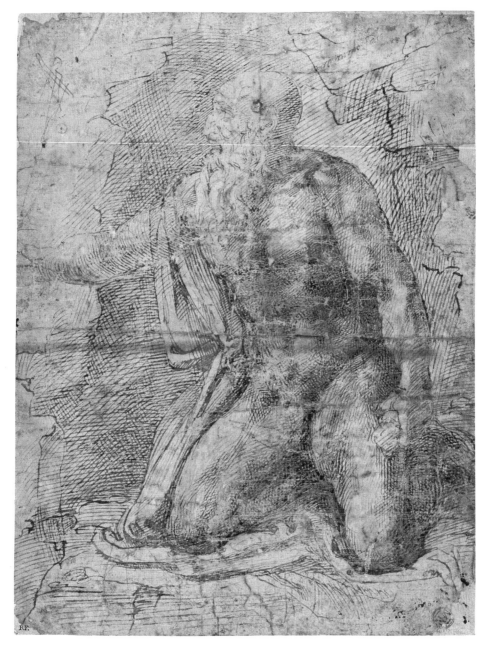

32. *Saint Jerome*

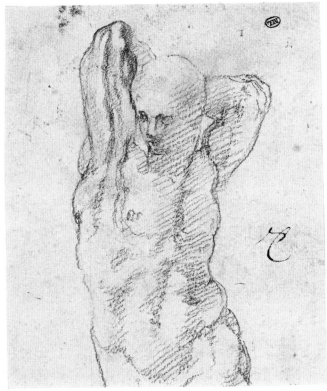

33. *Six architecture profiles*

34. *Half-length male, full-frontal view*

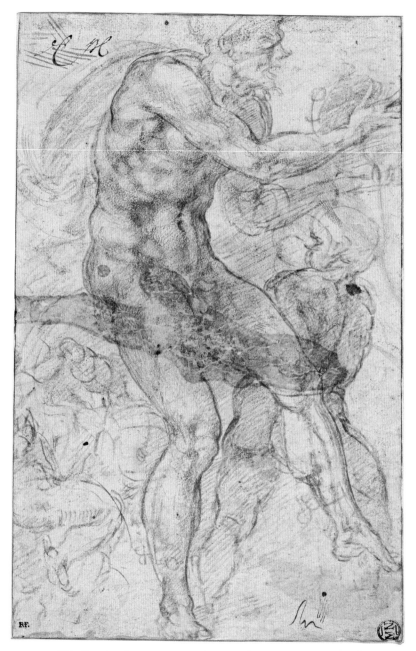

35. *Dancing faun, a putto* and *a recumbent woman near a cask*

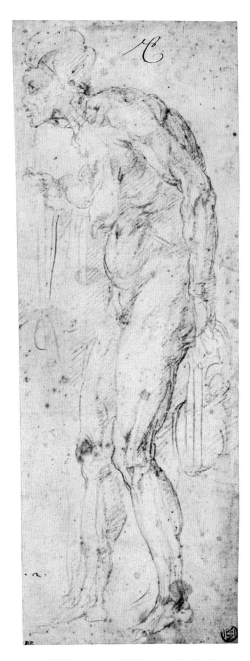

36. *Elderly woman, holding a* viola da braccio

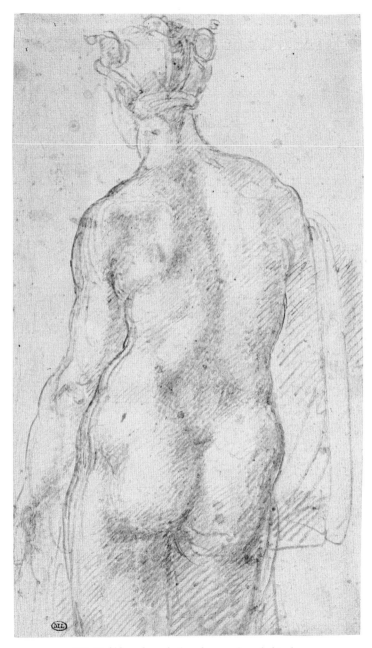

37. *Half-length nude female seen from behind*

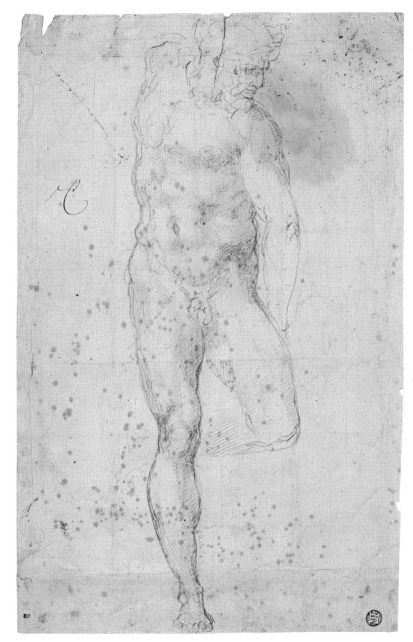

38. *Study for a Slave*

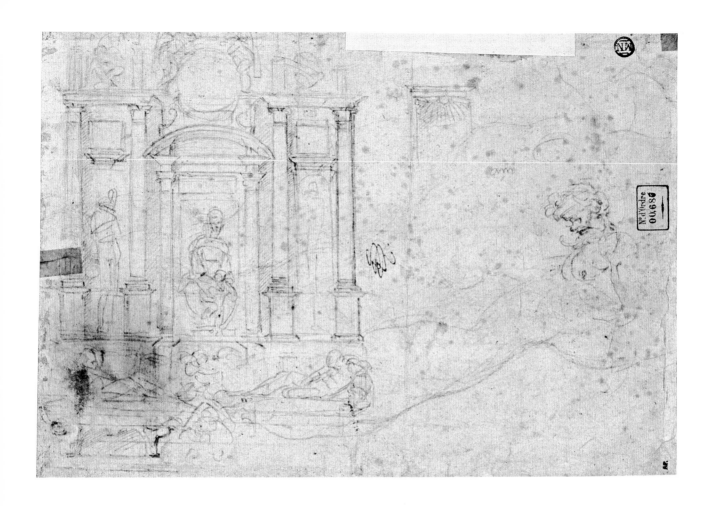

39. *Sketches for the Tomb of the Magnifici; sketch of a term*

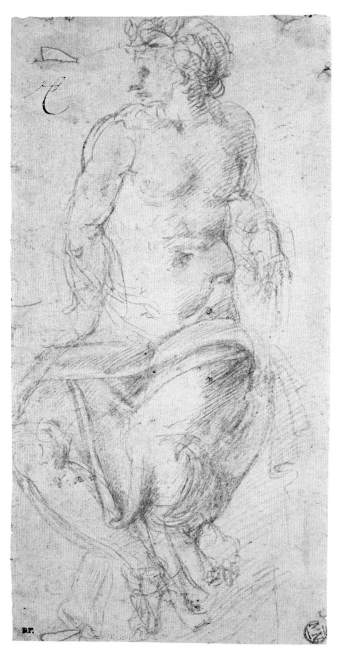

40. *Seated figure: Saint Cosmas (?)*

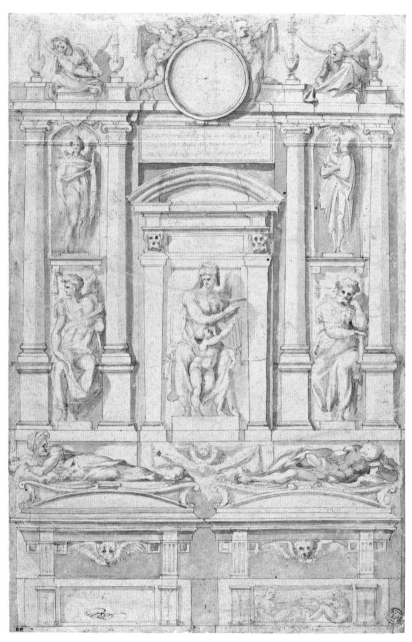

41. *Model for the Tomb of the Magnifici.*

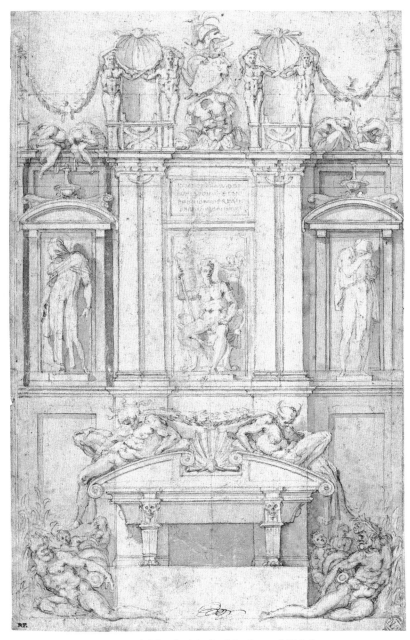

42. *Model for the Tomb of Giuliano de' Medici*

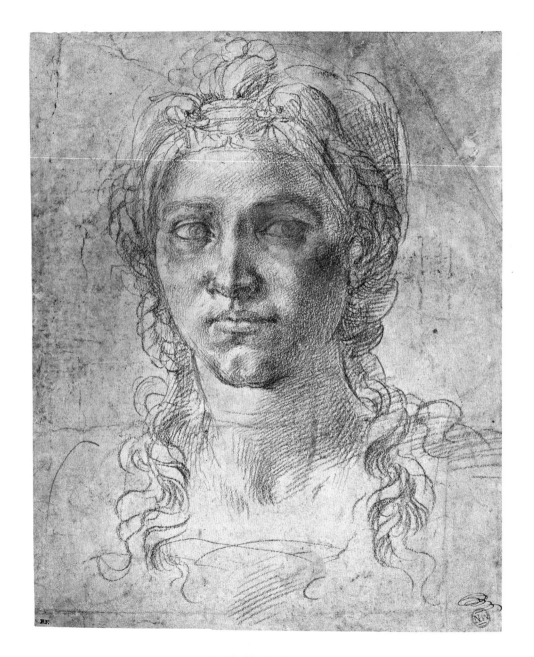

43. *Ideal head of a woman*

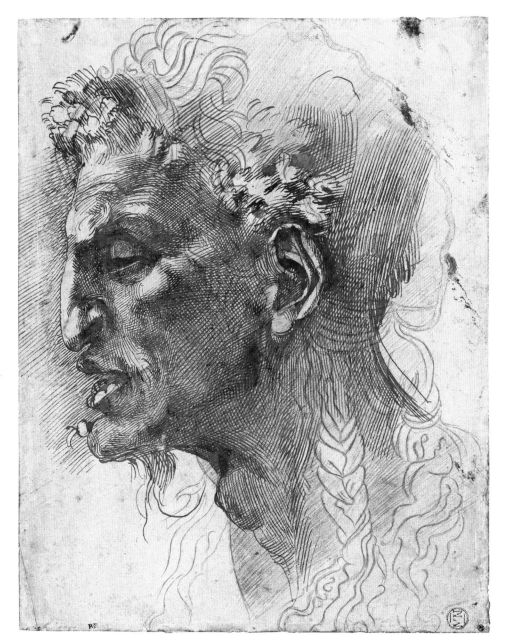

44. *Head of a faun*

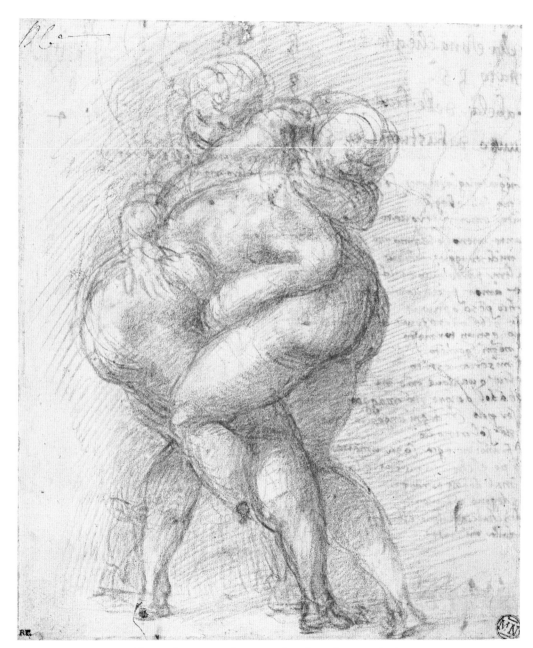

45. *Two nude men wrestling; partial outline of an upright figure*

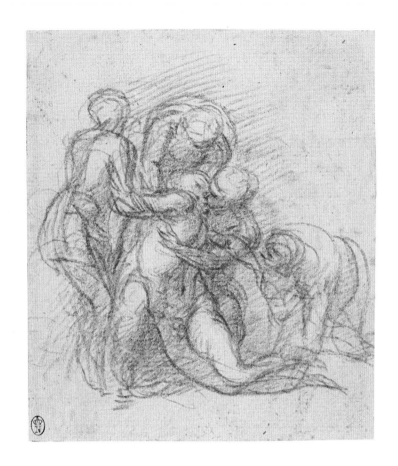

46. *Study for a Deposition of Christ*

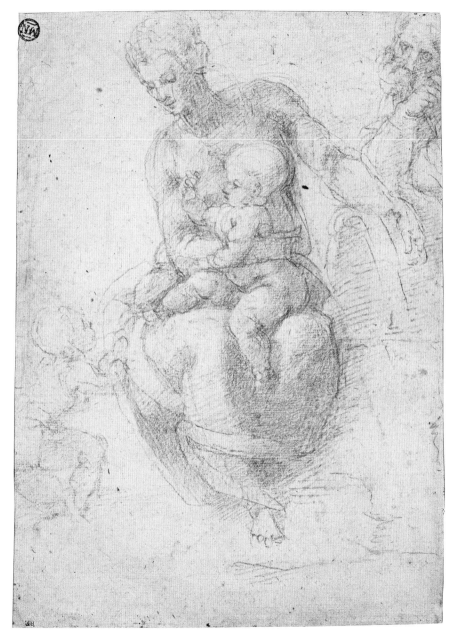

47. *Virgin and Child with Saint John the Baptist and Saint Joseph*

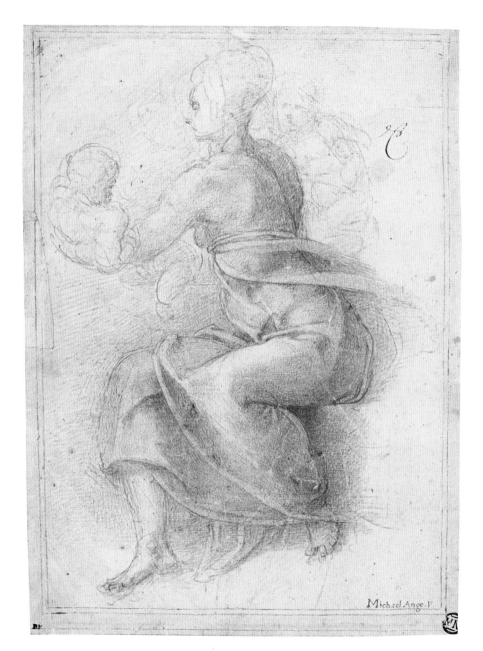

48. *Virgin and Child with Saint John the Baptist*

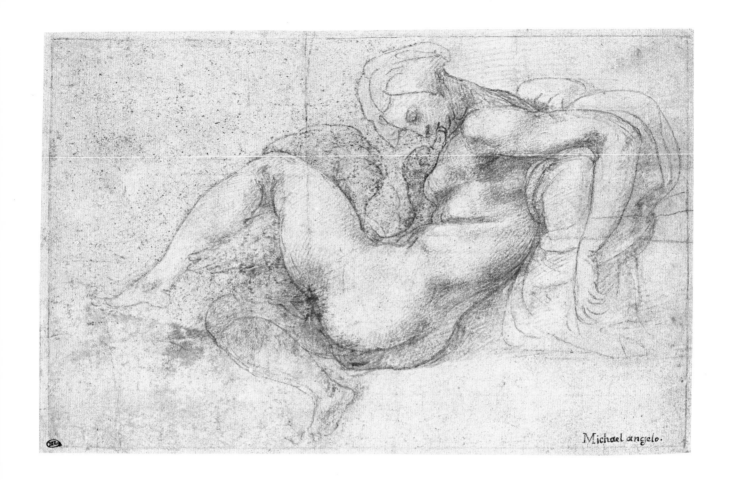

49. *Leda and the Swan*

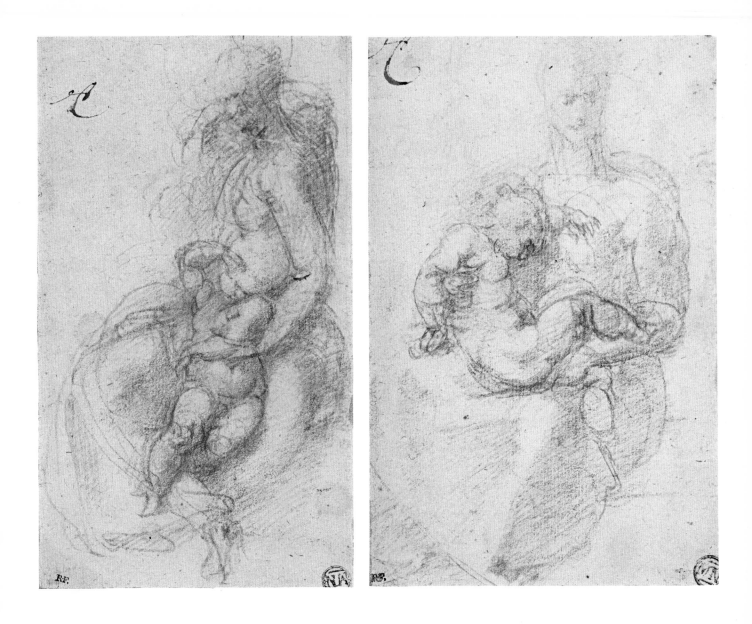

50. *Seated Virgin and Child, seen in left profile* **51.** *Seated Virgin and Child; fragment of drapery*

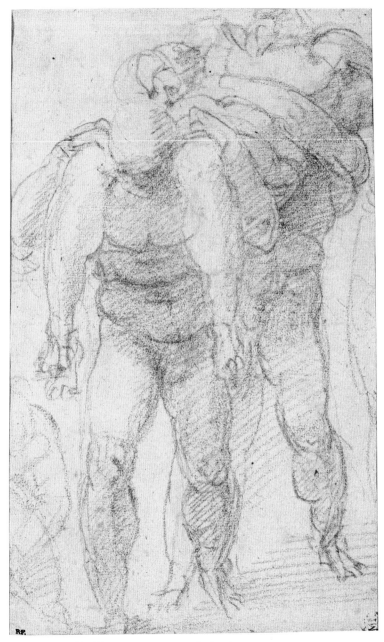

52. *Three men carrying a body: the Deposition (?)*

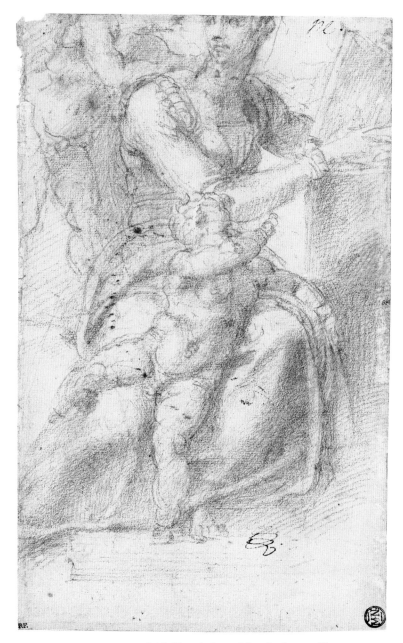

53. *Virgin and Child with Saint John the Baptist* (?)

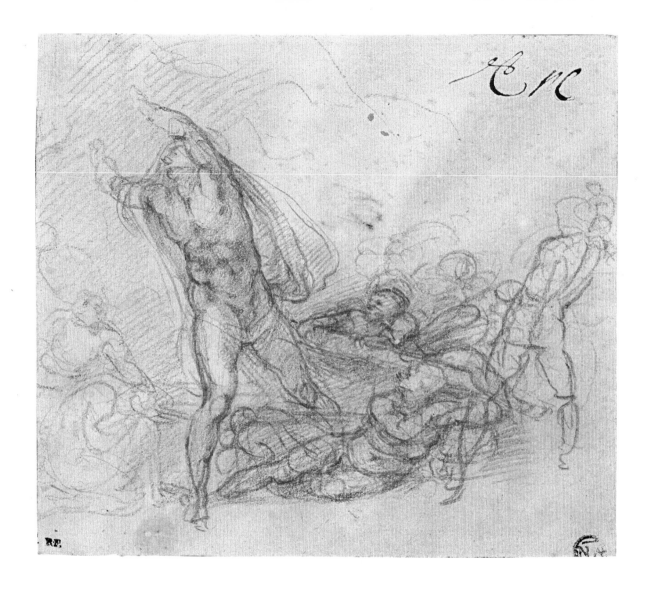

54. *Resurrection of Christ, with nine guards*

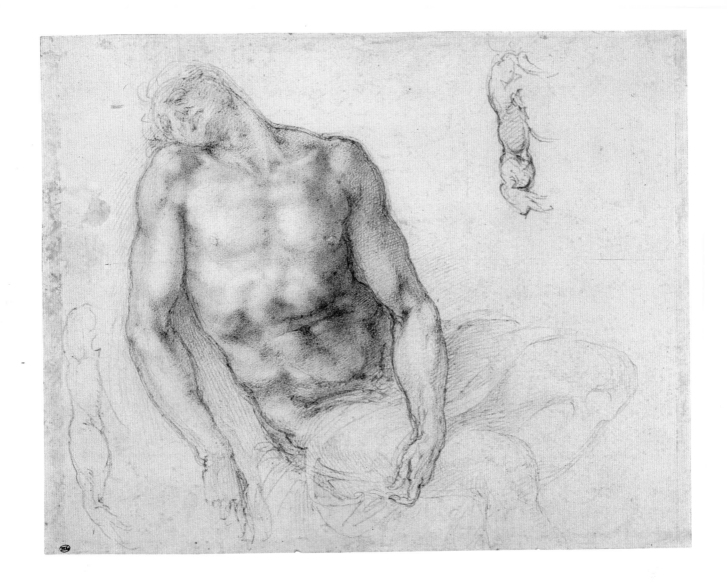

55. *Dead Christ and two corrections of the right arm*

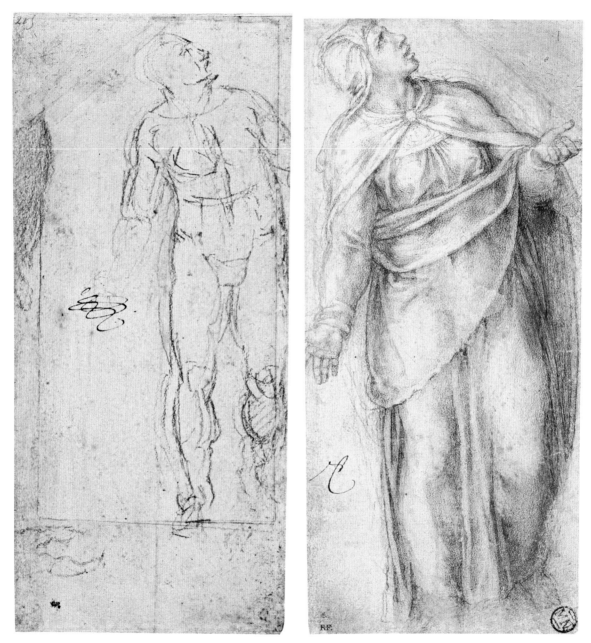

56-57. *Studies for the Virgin at the foot of the Cross*

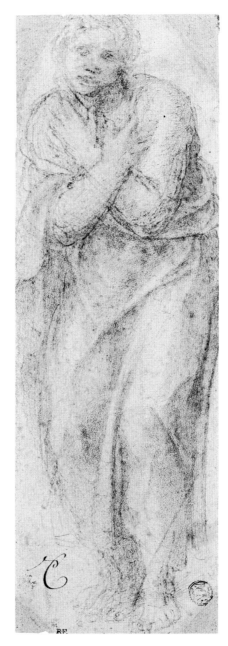

58. *Saint John at the foot of the Cross*

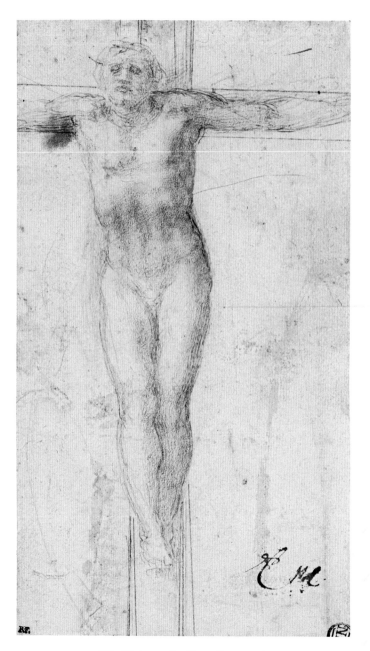

59. *Christ on the Cross* (fragment)

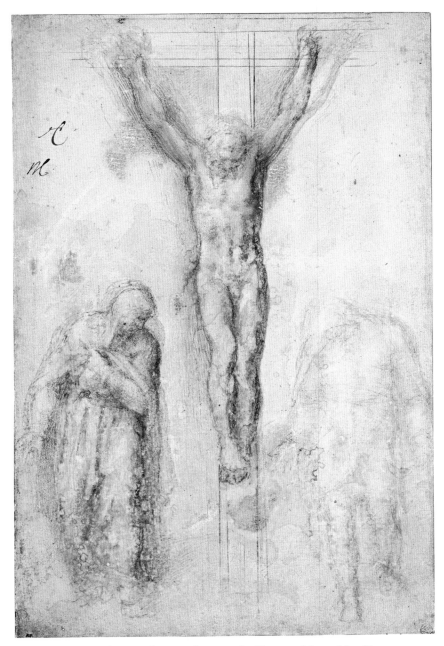

60. *Christ on the Cross between the Virgin and Saint John* (?)

61. *Section of the vault designed for the Chapel of the King of France in San Pietro, in Rome*

62. *Study for the casing of a door or a window*

Entries

by Dominique Cordellier
based on the inventory of Michelangelo's drawings
established by Paul Joannides and published in 2003

1. *The Ascension of the Evangelist, copy after Giotto in the Cappella Peruzzi of Santa Croce, in Florence*
Pen and brown ink, corrected with grey ink on the right section of the standing figure and its foot, over stylus underdrawing. 318 × 205 mm.

Presumably prior to Michelangelo's copies after Masaccio preserved in Munich and in Vienna, these drawings attest to the revived interest in the *œuvre* of Giotto between 1480 and 1490 in the workshop of the artist's master, Domenico Ghirlandaio. The studies on the verso – *A left arm, a fragment of a torso, sketches and inscriptions* (not illustrated) – that perhaps should be connected with the execution of his marble *David* (circa 1502 – 1503), utilise red chalk, which Michelangelo probably did not use before 1500. Prov.: Paraph of Brigand, notary at the Châtelet of Paris (?) – Cabinet du Roi. Inv. 706. JOANNIDES 2003, n. 1r.

2. *Mary-Magdalene (?) gazing at the crown of thorns*
Pen and brown ink, worked over with a pen in darker ink, heightened in white gouache with a brush, over traces of black chalk; white paper partly washed and rubbed with minium; vertical line in black chalk near the left margin, and traces of a diagonal line from upper left to lower right. 258 × 153 mm.

Some historians exclude this drawing from Michelangelo's *œuvre*, and suggest either leaving it anonymous or discerning in it the hand of Passerotti, of the Master of the Manchester Madonna, of Agnolo di Donnino di Domenico del Mazziere or of Bandinelli. However, this is an autograph study by Michelangelo for a figure of the *Entombment*, probably intended for Giovanni Ebu's chapel in the Roman church of Sant'Agostino, for which the artist had been commissioned in the fall of 1500. Today the painting is at the National Gallery of London.
Prov.: E. Jabach, drawing catalogued as "remainder" – Purchased for the Cabinet du Roi in 1671. Inv. 726. JOANNIDES 2003, n. 2r.

3. *The Expulsion from Paradise, copy after Masaccio in the Cappella Brancacci of Santa Maria del Carmine, in Florence*
Red chalk and stump, a few stylus strokes. 326 × 187 mm.

Discovered before 1966 by Oberhuber among Raphael's drawings, this copy after Masaccio's fresco shows that Michelangelo, at the time he was designing the *Battle of Cascina* for the Palazzo della Signoria of Florence, looked for inspiration to the great example of Masaccio, who had been capable, eighty years earlier, of creating a new image of Man.
Prov.: I. and Ch. Desneux – F. de la Noüe – E. Jabach, drawing catalogued as "remainder" – Purchased for the Cabinet du Roi in 1671. Inv. 3897. JOANNIDES 2003, n. 3r.

4. *Studies of figures, several for the Battle of Cascina*
Black chalk over scattered stylus marks; stylus; traces of red chalk. 201 × 78 mm.

Perhaps one of the first studies for figures of the *Battle of Cascina*, the cartoon of which Michelangelo prepared in 1504 – 1505 for a painting for the main hall of the Palazzo della Signoria in Florence.
Prov.: E. Jabach, drawing catalogued as "remainder" – Purchased for the Cabinet du Roi in 1671. Inv. 726. JOANNIDES 2003, n. 2v.

5. *Three figures running, for the Battle of Cascina*
Red chalk, traces of black chalk. 326 × 187 mm.

Discovered before 1966 by Oberhuber among Raphael's drawings, this study by Michelangelo belongs to the experiments he undertook in 1504 for the cartoon of the *Battle of Cascina*, a monumental painting for the Main Hall of the Palazzo della Signoria in Florence.
Prov.: I. and Ch. Desneux – F. de la Noüe – E. Jabach, drawing catalogued as "remainder" – Purchased for the Cabinet du Roi in 1671. Inv. 3897. JOANNIDES 2003, n. 3v.

6. *Sketch for the bronze David and other studies*
Pen and brown ink; antique restoration of the paper in lower right and lower left corners. 264 × 185 mm.

Study for a bronze statue of *David*, for which Michelangelo signed the execution contract on 12 August 1502 in reply to a request that Pierre de Rohan, Marshall of Gié and minister of the King of France, Louis XII, had addressed to the Signoria of Florence. The work, cast in 1503, was finally delivered to Florimont Robertet in 1508 after having been completed by Benedetto da Rovezzano. Today, like most of Michelangelo's works sent to France, it is lost.
Prov.: P. Crozat – P.-J. Mariette – Marquis de Lagoy – S. Woodburn – Th. Dimsdale – S. Woodburn – Sir Th. Lawrence – S. Woodburn – William II, King of the Netherlands – Purchased for the Louvre in 1850. Inv. 714. JOANNIDES 2003, n. 4r.

7. *Studies of various figures*
Pen and brown ink; traces of black chalk. 264 × 185 mm.

Occasionally connected with a low relief by Jacopo della Quercia that Michelangelo may have seen at Bologna in 1494 – 1495, or with the background of his fresco of the *Drunkenness of Noah* painted in 1509 on the ceiling of the Cappella Sistina, this drawing of 1502 – 1503 may have been used, according to Joannides, for the preparation of the *Ten Thousand Martyrs* that Michelangelo planned around 1502 – 1506.
Prov.: P. Crozat – P.-J. Mariette – Marquis de Lagoy – S. Woodburn – Th. Dimsdale – S. Woodburn – Sir Th. Lawrence – S. Woodburn – William II, King of the Netherlands – Purchased for the Louvre in 1850. Inv. 714. JOANNIDES 2003, n. 4v.

8. *Saint John the Evangelist*
Pen and brown ink over black chalk. Traces of a thin framing line in pen and brown ink on lower edge. 201 × 78 mm.

Discovered in 1991 by Cordellier among the anonymous Italian School drawings, this drawing is a study for one of the statues of the twelve Apostles that Michelangelo, according to the terms of a contract dated 24 April 1503, was supposed to execute in marble for the Florence Duomo. The fragmented sketches on the verso (not illustrated) combine a study for a *Saint John the Evangelist* with elements of the capital, probably for the niche where the statue was to have been placed. Another fragment of the same sheet, bearing additional studies, is in London, at the British Museum (inv. 1895-9-496 verso). This figure inspired a sculpture by Alonso Berruguete (Valladolid, Museo Nacional de Escultura).
Prov.: E. Jabach, drawing catalogued as "remainder" – Purchased for the Cabinet du Roi in 1671. Inv. 12691. JOANNIDES 2003, n. 5r.

9. *Figure for the Battle of Cascina*
Pen and brown ink over black chalk, stump and stylus marks. 250 × 96 mm.

Study for one of the soldiers putting his clothes on in the *Battle of Cascina*, of which Michelangelo designed the cartoon in 1505 – 1506 for a painting for the Main Hall of the Palazzo della Signoria in Florence. The artist borrowed the posture of the figure from a sculpture design for the Tomb of Julius II. This drawing, probably brought to France by Michelangelo's pupil, Antonio Mini, as early as 1531, was used by Francesco Primaticcio in a composition of the Galerie d'Ulysse in the Château of Fontainebleau (today destroyed). This drawing is transferred by transparency on the verso (not illustrated).
Prov.: E. Jabach, drawing catalogued as "remainder" – Purchased for the Cabinet du Roi in 1671. Inv. 712. JOANNIDES 2003, n. 7r.

10. *Study of a figure for the Battle of Cascina*
Black chalk. Upper left corner cut and reconstituted. 282 × 203 mm.

For a long time deemed a copy, this drawing of a figure for the *Battle of Cascina* that Michelangelo had planned to paint in the Palazzo della Signoria in Florence, was re-attributed to Michelangelo by Delacre in 1938, and, more recently, by Joannides and Hirst. The verso (not illustrated) is too weak an execution to be attributed to Michelangelo.
Prov.: G. Vasari (?) – E. Jabach, drawing catalogued as "remainder" – Purchased for the Cabinet du Roi in 1671. Inv. 713. JOANNIDES 2003, n. 6r.

11. *Nude man, in profile, bounding to the right; detail of frontal representation of a right shoulder (?), decorative motif*
Black chalk over stylus marks. Framing line in pen and brown ink. 290 × 196 mm.

Usually connected with one of the figures for the composition of the Archers drawn by Michelangelo circa 1530, but in fact with motifs borrowed from an antique sarcophagus – the Sarcophagus of Medea – this drawing, whose rendering is akin to that of Michelangelo's sheets from around 1505, should be associated, according to Joannides, with the artist's essays, either for the *Ten Thousand Martyrs* he planned to execute around 1502 – 1506, or for the *Battle of Cascina* he was supposed to paint for the Palazzo della Signoria in Florence.
Prov.: Cabinet du Roi. Inv. 707. JOANNIDES 2003, n. 8.

12. *Two male nudes raising a third male nude*
Black chalk and stump, over stylus marks. 334 × 174 mm.

This drawing, whose attribution to Michelangelo has been the subject of scarce discussion, should be associated, according to Joannides, not (as Berenson and Hirst supposed) with the artist's essays for the *Battle of Cascina* that Michelangelo was supposed to paint in the Palazzo della Signoria in Florence, but rather with those in preparation for the *Ten Thousand Martyrs* he planned circa 1502 – 1506.
Prov.: A. Mini (?) – Unidentified early seventeenth-century French collector – P. Crozat – P.-J. Mariette – Saint-Morys; confiscation of the property of the Emigrés in 1793, entrusted to the Muséum central des Arts in 1796 – 1797. Inv. 718. JOANNIDES 2003, n. 9r.

13. *Six studies of figures: two drawn vertically (in the same direction as the recto), and four drawn horizontally*
Black chalk, pen and brown ink. 174 × 334 mm.

The rear-view sketches are reminiscent of the drawings related to the marble *David*, executed circa 1502 – 1503. The outlined nude should be associated with plate 17 and perhaps connected with the *Ten Thousand Martyrs* that Michelangelo planned circa 1502 – 1506. The other studies may be the first *pensieri* for the *Battle of Cascina* that Michelangelo was to have painted in the Palazzo della Signoria in Florence.
Prov.: A. Mini (?) – Unidentified early seventeenth-century French collector – P. Crozat – P.-J. Mariette – Saint-Morys; confiscation of the property of the Emigrés in 1793, entrusted to the Muséum central des Arts in 1796 – 1797. Inv. 718. JOANNIDES 2003, n. 9v.

14. *Male nude seen from behind, and other studies*
Pen and brown ink with traces of black chalk. 271 × 203 mm.

Sometimes excluded from Michelangelo's œuvre (without good reason), this sheet, which is akin to the artist's ideas for his bronze *David* intended for the Marshall of Gié, and which some historians connect with the working sheets for the *Battle of Cascina* Michelangelo was to have painted for the Palazzo della Signoria in Florence, cannot be linked with certainty to any of Michelangelo's

known projects. The studies of helmets may have been done, according to Joannides, in preparation for the *Ten Thousand Martyrs*, which the artist planned to execute circa 1502 – 1506. Another drawing of the same figure is in the Albertina (inv. 118). Prov.: Sixteenth-century Italian collector (?) – Sixteenth- or early seventeenth-century Italian collector – J. Sandrart (?) – P. Spiering Silfverkroon (?) – Christina of Sweden (?) – Cardinal Decio Azzolini – Don Livio Odescalchi, Duke of Bracciano (?) – P. Crozat (?) – Cabinet du Roi (?). Inv. 727. JOANNIDES 2003, n. 10r.

15. *Studies of heads and helmets*
Pen and brown ink with traces of black chalk. 271 × 203 mm.

Elaborating on a frequent theme in Florence in the fifteenth century and anticipating the *Ideal Heads* Michelangelo would draw much later, these studies of heads of helmetted men may have been done for representations of the tormentors in the *Ten Thousand Martyrs* that the artist planned to execute circa 1502 – 1506. Prov.: Sixteenth-century Italian collector (?) – Sixteenth- or early seventeenth-century Italian collector – J. Sandrart (?) – P. Spiering Silfverkroon (?) – Christina of Sweden (?) – Cardinal Decio Azzolini – Don Livio Odescalchi, Duke of Bracciano (?) – P. Crozat (?) – Cabinet du Roi (?). Inv. 727. JOANNIDES 2003, n. 10v.

16. *Full-frontal male nude*
Pen and brown ink, touches of wash, a few stylus contours and lines; partly squared in black chalk. 337 × 162 mm.

Squared as if to be used elsewhere, this highly classical nude study (in which the artist oddly neglected drawing the genitals) has not been connected with any of Michelangelo's known projects. Dating in all likelihood from 1505, it is probably concurrent with his essays for the *Slaves* on the Tomb of Julius II. Prov.: P.-J. Mariette – E. Gatteaux; bequest in 1881. Inv. RF 1068. JOANNIDES 2003, n. 11r.

17. *Various studies of figures; inscriptions*
Pen and brown ink, black chalk and stylus. 337 × 162 mm.

The main figure may be a study for one of the victims of the *Ten Thousand Martyrs* that the artist planned to execute circa 1502 –

1506. The secondary sketch recalls, without being an exact match, the *Moses* that Michelangelo represented on a model for the Tomb of Julius II in the Uffizi in Florence (608 E). The drawing of the right arm may be either a first *pensiero* for the figure on the recto (pl.16), or for the figure drawn on plate 21. Prov.: P.-J. Mariette – E. Gatteaux; bequest in 1881. Inv. FR 1068. JOANNIDES 2003, n. 11v.

18. *Two studies of seated figures, one holding a child*
Pen and brown ink over stylus marks; traces of black chalk (?) put on to another paper support. 375 × 197 mm.

Drawn after a male model, these two studies of a woman with a child may have been preparatory drawings for a representation of the Virgin and Child with Saint Anne, of which we know from other sketches in Michelangelo's *œuvre*. Drawn circa 1506, they form a noteworthy precedent for the *Medici Madonna* (San Lorenzo, Florence), carved in the years 1521 – 1534, and for a presentation drawing dating from the early 1540s (Windsor). Prov.: E. Jabach, compositional drawing missing its gilt band mount – Purchased for the Cabinet du Roi in 1671. Inv. 689. JOANNIDES 2003, n. 12v.

19. *Male nude, frontal view*
Pen and brown ink, in part over stylus marks and black chalk strokes, corrected with a darker ink on the two legs and around the waist. 375 x 197 mm.

Widely considered, in particular by Gould and Hirst, to be a study for one of the figures for the *Entombment* (now in the National Gallery, London) presumably intended for Giovanni Ebu's chapel in the Roman church of Sant'Agostino, and which had been commissioned to the artist in the fall of 1500, this drawing, characteristic of the years 1505 – 1506, cannot be securely associated to any of Michelangelo's known designs. Joannides, refuting the comparisons with the marble *David* and the *Victory*, probably designed for the Tomb of Julius II, (as respectively put forward by Echinger-Maurach and Wölfflin), suggests viewing it as a working sheet for one of the sufferers of the *Ten Thousand Martyrs*, which the artist planned to execute circa 1502 – 1506.
Prov.: E. Jabach, compositional drawing missing its gilt band mount –

Purchased for the Cabinet du Roi in 1671. Inv. 689.
Joannides 2003, n. 12r.

20. *Various studies of figures; inscription after a sonnet by Petrarch*
Pen and several tones of brown ink, black chalk. 402 × 215 mm.

Transferred by transparency, doubtless by Michelangelo himself, from the drawing on the recto (pl.21). The sketch in the lower left is likely a practice drawing for one of the *Slaves* on the Tomb of Julius II, as planned by Michelangelo in 1505. Other details are presumably also preparatory drawings for one of the *Slaves*. The *putto* may have served (in reverse) for the young Saint John of the "Doni Tondo" probably painted in 1506, albeit with a posture that is closer to that of the same saint in the *Manchester Madonna* (National Gallery, London).
Prov.: Cabinet du Roi. Inv. 688. Joannides 2003, n. 13v.

21. *Frontal view of male nude (Mercury/Apollo); man carrying a burden*
Pen and brown ink, worked over with a grey ink. 402 × 215 mm.

Steeped in the recollection of a statue of *Hermes* corresponding to a Praxiteles type, various copies of which could be seen in Rome, this study of *Mercury* (bearing his winged petasus) appears to have been altered by Michelangelo into an *Apollo* (holding his *viola da braccio*, drawn subsequently), that is, unless, as Thode suggested, the artist had intended from the start to represent Mercury as inventor of the lyre (which at the time was identified with the *viola da braccio*). Based on this assumption, this work could be a study for a low relief on the theme of the Golden Age for the Tomb of Julius II (but never executed). The other study on the sheet, vaguely inspired by a *putto* carrying a Hellenistic-style amphora once in the Cesi gardens in Rome, is not connected with any specific design, but is reminiscent of the *Slaves* on the Tomb of Julius II, and the first *Ignudi* of the Cappella Sistina vault.
Prov.: Cabinet du Roi. Inv. 688. Joannides 2003, n. 13r.

22. *Male nude seen from behind*
Pen and brown ink, partly corrected with black chalk.
240 × 82 mm.

Discovered in 1991 by Cordellier among the drawings of the school of the Carraccis and connected by him with the *Battle of Cascina* and the relief of the *Fall of the Manna of the Della Rovere Acorns* sketched for the Tomb of Julius II in 1505 (Metropolitan Museum of Art, New York), this drawing cannot be related to any known works by the artist.
Prov.: E. Jabach, drawing catalogued as "remainder" – Purchased for the Cabinet du Roi in 1671. Inv. 8026. Joannides 2003, n. 15r.

23. *Study for a seated prophet*
Pen and brown ink, black chalk, stump and black chalk corrections. 209 × 114 mm.

Study from the life of the prophet, which can be seen on a drafted model of the Tomb of Julius II in the Metropolitan Museum of Art, New York, and dating presumably from 1505, when the monument was still being conceived as a wall tomb. Left section of a sheet, of which the right section is presented in plate 22.
Prov.: E. Jabach, drawing catalogued as "remainder" – Purchased for the Cabinet du Roi in 1671. Inv. 722. Joannides 2003, n. 14r.

24. *The Tomb of Julius II, part of the elevation*
Pen and brown ink, over ruled outline, with stylus and black chalk; the lower section free-hand, in black chalk; compass guidemarks. Unevenly cut. Maximum dimensions: 240 × 82 mm.

Discovered in 1991 by Cordellier on the verso of a drawing classified among the sheets belonging to the school of the Carracis, this study for the Tomb of Julius II is a variation on the antique model of the *Arco del Portogallo* (now lost). It illustrates the part of the upper level that was to be placed on a base the size of the one planned in 1505, when the monument was to be free-standing rather than a wall tomb. Left section of a sheet, of which the right section is presented in plate 25.
Prov.: E. Jabach, drawing catalogued as "remainder" – Purchased for the Cabinet du Roi in 1671. Inv. 8026. Joannides 2003, n. 15v.

25. *The Tomb of Julius II, part of the elevation*
Ruled, in black chalk and stylus, partly corrected in the upper section with pen and brown ink. Unevenly cut.

Maximum dimensions: 209 × 114 mm.

Discovered in 1990 while the sheet was being unglued, this study for the Tomb of Julius II, is a variation on the antique model of the *Arco del Portogallo* (now lost). It illustrates the part of the upper level that was to be placed on a base the size of the one planned in 1505, when the monument was to be free-standing rather than a wall tomb. Right section of a sheet, of which the left section is presented in plate 24.
Prov.: E. Jabach, drawing catalogued as "remainder" – Purchased for the Cabinet du Roi in 1671. Inv. 722. JOANNIDES 2003, n. 14v.

26. *Salome with the head of Saint John the Baptist or the servant of Judith with the head of Holofernes; inscriptions*
Pen and brown ink, partly corrected in black chalk. 324 × 260 mm.

None of these motifs can be related with certainty to any known designs of Michelangelo. The principal figure, whose model is the Salome painted by Filippo Lippi at Prato, as Goldscheier demonstrated, can be read as Herodias or Salome carrying the head of Saint John the Baptist, or as Abra, Judith's servant, carrying the head of Holofernes. Perhaps, as Berenson suggested, it may be a preliminary idea for the *Judith* Michelangelo painted on the Cappella Sistina ceiling. As Poggi established, the text is that of a contract drawn up by Michelangelo's great grandfather; thus, Michelangelo here reutilises a sheet already used in the late fourteenth or early fifteenth century.
Prov.: P.-J. Mariette – Saint-Morys; confiscation of the property of the Émigrés in 1793, restituted to the Muséum central des Arts in 1796-1797. Inv. 685. JOANNIDES 2003, n. 16v.

27. *The Virgin and Child with Saint Anne; a male nude; inscriptions after a sonnet by Petrarch*
Pen and brown ink, corrected in black chalk with a few stylus (?) marks; the main subject worked over with darker ink.
324 × 260 mm.

None of these motifs can be related with certainty to any known designs of Michelangelo. Wilde observed that the Virgin had been drawn from a *Sibyl* carved by Giovanni Pisano for the pulpit of Pistoia, while Thode noticed that the grouping of Saint Anne with the Virgin and Child recalled the theme formerly treated by

Leonardo da Vinci in Florence (cartoon in National Gallery, London; painting in the Louvre). The model for the male nude, probably drawn subsequently, is the same [as the] one who posed for Michelangelo for the drawing in plate 23. Joannides suggests seeing in it an eventual study for one of the executors of the *Ten Thousand Martyrs*, which the artist planned to execute circa 1502 – 1506. The inscriptions are in part drawn from the sonnet CXXIX by Petrarch.
Prov.: P.-J. Mariette – Saint-Morys; confiscation of the property of the Émigrés in 1793, restituted to the Muséum central des Arts in 1796-1797. Inv. 685. JOANNIDES 2003, n. 16r.

28. *The Virgin standing with the Child and Saint John; poem*
Pen and brown ink. 310 × 220 mm.

None of these studies can be related with certainty to any known designs of Michelangelo. It is not known whether they were meant for a painting or a low relief. The type of the Child, however, is less sculptural than usual, and is similar to that of the works of an intimate of Michelangelo's circa 1500, Pietro d'Argenta. This suggests that the drawing could have been done by him. Michelangelo added the poem, rather farcical in tone, circa 1520.
Prov.: B. Buontalenti – M. Buonarroti the Younger – Baron Ph. Von Stosch – J.-B. Wicar – Lord Fitzwilliam – M. O. Midgeman Simpson – L. Bonnat; donation in 1912. Inv. RF 4112. JOANNIDES 2003, n. 17v.

29. *Two compositions showing the Virgin seated with the Child and Saint John; inscriptions*
Pen and brown ink, line of stylus marks. 310 × 220 mm.

None of these motifs can be related with certainty to any known designs of Michelangelo. It is not known whether they were studies intended for a painting or a low relief, or whether Michelangelo drew them for himself or for another artist. One of the two studies, the one presented here horizontally, borrows the pyramidal principle of Leonardo da Vinci's *Virgin and Child with Saint Anne* (Louvre). The treatment of the drapery is comparable to that of the *Prophets*, the *Sibyls* or the *Ancestors of Christ* of the Cappella Sistina. The inscription is neither from the hand of Michelangelo, nor that of his pupil, Antonio Mini.
Prov.: B. Buontalenti – M. Buonarroti the Younger – Baron Ph.

Von Stosch – J.-B. Wicar – Lord Fitzwilliam – M. O. Midgeman Simpson – L. Bonnat; donation in 1912. Inv. RF 4112. JOANNIDES 2003, n. 17r.

30. *Sketch for the Ignudo above and to the left of Isaiah; outline of a right hand and forearm; inscriptions*
Black chalk and stump, stylus marks, traces of incisions. 307 × 207 mm.

A study, no doubt done prior to the one on the recto (pl. 31), for one of the *Ignudi* painted, presumably in 1509, in the third section of the vault of the Cappella Sistina. This is a variation on a figure in the background of the "Doni Tondo" (Uffizi, Florence). Prov.: Buonarroti (?) – E. Jabach, drawing catalogued as "remainder" – Purchased for the Cabinet du Roi in 1671. Inv. 860. JOANNIDES 2003, n. 19v.

31. *Head and right hand of the Ignudo above and to the left of Isaiah, on the vault of the Cappella Sistina*
Black chalk and highlighting in white. 307 × 207 mm.

Study from life for the head of one of the *Ignudi* painted, presumably in 1509, in the third section of the vault of the Cappella Sistina.
Prov.: Buonarroti (?) – E. Jabach, drawing catalogued as "remainder" – Purchased for the Cabinet du Roi in 1671. Inv. 860. JOANNIDES 2003, n. 19r.

32. *Saint Jerome*
Pen and brown ink, worked over with a pen and a darker ink. Two slanting annotations in pen and brown ink, upper right, probably by the artist: *ieronimo sa[n]cto.* 286 × 211 mm.

Finished drawing, annotated from the artist's hand, probably for an otherwise unknown painting. As remarked by Tolnay, the bust of the saint is drawn from the fragmented statue of a Greek "Hercules", which is signed Apollonius, and known as the *Belvedere Torso* (Vatican), one of Michelangelo's favorite sources throughout his career. The saint's head presents a likeness with that of the prophet *Zeccharia* painted on the vault of the Cappella Sistina. Prov.: E. Jabach, compositional drawing missing its gilt band mount – Purchased for the Cabinet du Roi in 1671. Inv. 705.

JOANNIDES 2003, n. 18.

33. *Six architecture profiles*
Red chalk. 129 × 107 mm.

Discovered in 1991 by Joannides among the drawings of Francesco Primaticcio, these studies of cornices bring to mind Michelangelo's copies after the Coner Codex (Sir John Soane's Museum, London). They may be designs for the Tomb of Julius II, or for the façade of San Lorenzo in Florence. Prov.: A. Mini (?) – Fr. Primaticcio (?) – E. Jabach, drawing catalogued as "remainder" – Purchased for the Cabinet du Roi in 1671. Inv. 8676. JOANNIDES 2003, n. 20v.

34. *Half-length male, full-frontal view*
Red chalk. 129 × 107 mm.

Discovered in 1991 by Joannides among the drawings of Francesco Primaticcio, this drawing was perhaps a preparatory drawing for one of the *Slaves* on the Tomb of Julius II. In all likelihood, it was brought to France by Michelangelo's pupil, Antonio Mini, and used by Francesco Primaticcio in a drawing for a fresco for the Ballroom in the Château of Fontainebleau. Prov.: A. Mini (?) – Fr. Primaticcio (?) – E. Jabach, drawing catalogued as "remainder" – Purchased for the Cabinet du Roi in 1671. Inv. 8676. JOANNIDES, 2003 n. 20r.

35. *Dancing faun, a* putto *and a recumbent woman near a cask*
Red chalk, traces of black chalk counter-proof, pen strokes and brown ink. 271 × 173 mm.

A fragmented composition, no doubt connected with a painting that Alfonso d'Este, Lord of Ferrara, commissioned to Michelangelo in 1512, for his *camerino d'albastro.* Prov.: E. Jabach, drawing catalogued as "remainder" – Purchased for the Cabinet du Roi in 1671. Inv. 697. JOANNIDES 2003, n. 21r.

36. *Elderly woman in left profile, holding a stick in her right hand, and in the other a* viola da braccio
Black chalk, incised contours. 378 × 129 mm.

In a technique characteristic of circa 1520, this drawing should

likely be connected with one of the reliefs featuring a pagan motif – such as *Orpheus playing the lyre* – of the first designs for the Tomb of the Magnifici in San Lorenzo. Right section of a sheet, of which plate 37 shows the left section. On the verso (not illustrated), fragmented study for a *Virgin and Child with Little Saint John*, or for an *Eve with Cain and Abel*, or a *Charity*, whose purpose is not known, but is comparable in composition to a cartoon by Michelangelo done after 1530 for his pupil, Ascanio Condivi (British Museum, London).
Prov.: E. Jabach, drawing catalogued as "remainder" – Purchased for the Cabinet du Roi in 1671. Inv. 710. JOANNIDES 2003, n. 22r.

37. *Half-length nude female seen from behind*
Black chalk and stump, a few stylus strokes. 232 × 124 mm.

Study, in a technique characteristic of circa 1520, after the torso of an antique *Venus*, for which Michelangelo made other drawings (Casa Buonarroti, Florence; British Museum, London) when he was preparing the allegorical statues of the Sagrestia Nuova of San Lorenzo in Florence. Left section of a sheet, of which plate 36 shows the right section. On the verso (not illustrated), fragmented study for a *Virgin and Child with Little Saint John*, or for an *Eve with Cain and Abel*, or a *Charity*, whose purpose is not known, but comparable in composition to a cartoon by Michelangelo done after 1530, for his pupil, Ascanio Condivi (British Museum, London).
Prov.: E. Jabach, drawing catalogued as "remainder" – Purchased for the Cabinet du Roi in 1671. Inv. 725. JOANNIDES 2003, n. 23r.

38. *Study for a Slave*
Black chalk over strokes of red chalk, traces of stylus marks. 388 × 235 mm.

Identified by Thode as a study for one of the *Slaves* on the Tomb of Julius II designed in 1516, this drawing dates in all likelihood from the time when, around 1519, Michelangelo was thinking of altering and enlarging the *Slaves*. Probably brought to France by Michelangelo's pupil, Antonio Mini, it was used by Francesco Primaticcio in a drawing for a fresco for the vault of the Galerie d'Ulysse in the Château of Fontainebleau (destroyed).
Prov.: A. Mini (?) – Fr. Primaticcio (?) – E. Jabach, drawing

catalogued as "remainder" – Purchased for the Cabinet du Roi in 1671. Inv. 686. JOANNIDES 2003, n. 24v.
39. *Sketches for the Tomb of the Magnifici; sketch of a term*
Black chalk, compass pricks. 235 × 388 mm.

Studies, identified by Morel d'Arleux, for the double tomb of the Magnifici designed for the entrance wall of the Sagrestia Nuova of San Lorenzo in Florence. The bust of the ageing satyr may be the sketch of one of the terms forming a pilaster on the Tomb of Julius II, or belonging to the painting that Alfonso d'Este, Lord of Ferrara, had commissioned to Michelangelo in 1512, for his *camerino d'albastro*, that may have represented a Bacchanal. The light sketch of a bearded man at the bottom of the sheet may have been done by his a pupil.
Prov.: A. Mini (?) – Fr. Primaticcio (?) – E. Jabach, drawing catalogued as "remainder" – Purchased for the Cabinet du Roi in 1671. Inv. 686. JOANNIDES 2003, n. 24r.

40. *Seated figure: Saint Cosmas (?)*
Red chalk. 260 × 130 mm.

Identified by Thode as a sketch for the Tomb of the Magnifici in the Sagrestia Nuova of San Lorenzo in Florence.
Prov.: Cabinet du Roi. Inv. 708. JOANNIDES 2003, n. 25.

41. *Model for the Tomb of the Magnifici.*
Free-hand and ruled black chalk, brush and brown wash over stylus and compass marks; the central medallion (top), is underscored with a pen and brown ink. 379 x 242 mm.

While most historians deem this drawing to be a copy or variation after Michelangelo, Joannides holds it to be an autograph Model, made prior to 1521, for the Tomb of the Magnifici in the Sagrestia Nuova of San Lorenzo in Florence.
Prov.: E. Jabach, compositional drawing missing its gilt band mount – Purchased for the Cabinet du Roi in 1671. Inv. 837. JOANNIDES 2003, n. 26.

42. *Model for the Tomb of Giuliano de' Medici*
Free-hand and ruled black chalk, brush and brown wash, over black chalk lines and stylus and compass marks, traces of framing lines with a pen and brown ink. 321 × 203 mm.

While most historians deem this drawing to be a copy or variation after Michelangelo, Joannides holds it to be an autograph Model, made prior to 1521, for the Tomb of Giuliano de' Medici in the Sagrestia Nuova of San Lorenzo in Florence. Prov.: T. Dubreuil (?) – E. Jabach, compositional drawing missing its gilt band mount – Purchased for the Cabinet du Roi in 1671. Inv. 838. JOANNIDES 2003, n. 27.

43. *Ideal head of a woman*
Red chalk. 315 × 241 mm.

Classified in the seventeenth century under Michelangelo's name in the collection of E. Jabach, this drawing was discovered by Sutherland among the anonymous drawings of the seventeenth-century Italian School. It is one of the most natural ideal head studies that Michelangelo executed during the years 1520 – 1530. Prov.: E. Jabach, compositional drawing missing its gilt band mount – Purchased for the Cabinet du Roi in 1671. Inv. 12299. JOANNIDES 2003, n. 28.

44. *Head of a faun*
Pens, in two thicknesses, and brown ink, over a prior red chalk drawing. 277 × 213 mm.

The underlying red chalk drawing was probably from the hand of Michelangelo's pupil, Antonio Mini, after an *Ideal head* by Michelangelo (now lost, but known by one copy). It was corrected in pen and ink by Michelangelo himself. He turned the ideal forms into a terrifying, grotesque vision. This sheet, the purpose of which is unknown, borrows the theme of the *Faun* that Michelangelo had treated at an early age in sculpture (now lost). On the verso (not illustrated), an *Animal biting its tail*, presumably copied after a Michelangelo drawing by one of his pupils; a *Face viewed from the front*, was in all likelihood drawn by Michelangelo himself for didactic purposes for this same pupil (no doubt Antonio Mini). The small study of a man very likely reflects the work executed on the *Allegories* of the Cappella Medici in San Lorenzo (Florence). Prov.: A. Mini (?) – P.-J. Mariette; purchased for the Cabinet du Roi. Inv. 684. JOANNIDES 2003, n. 29r.

45. *Two nude men wrestling; partial outline of an upright figure, the arm and thigh extended on a parallel*

Red chalk. 237 × 193 mm.

The rendering, sweeping and pictorial, is that of the years around 1520. The subject of the drawing brings to mind the *Hercules and Antaeus* group requested of Michelangelo in 1505, and which he hoped to be able to treat in 1524, along with the *Jacob struggling with the Angel* that circa 1516 he planned to represent in a relief on the Tomb of Julius II. However, the sheet may not belong to any specific project. On the verso (not illustrated), the *Study of a Putto* was probably done by Michelangelo as a model for his pupil, Antonio Mini, who furthermore is the author of the inscriptions – a poem and some accounts – mentioning a certain Bastianino (Sebastiano). After 1524, several of Michelangelo's assistants were thus named. Prov.: Cabinet du Roi. Inv. 709. JOANNIDES 2003, n. 30r.

46. *Study for a Deposition of Christ*
Red chalk. 110 × 93 mm

Discovered prior to 1967 by Bean among the anonymous drawings of the Italian School, this sheet is connected with a study for a *Deposition* preserved in Haarlem (Teylers Museum, A 25) and used as a model for a number of reliefs in wax, clay and bronze, none of which are by Michelangelo's hand. On the verso (not illustrated), *A hand, a wrist (?) and a fragment of a shoulder*, not related to any known designs, but in a style comparable to that of the drawings for the *Last Judgement* in the Cappella Sistina in the Vatican. Prov.: E. Jabach, drawing catalogued as "remainder" – Purchased for the Cabinet du Roi in 1671. Inv. 10161. JOANNIDES 2003, n. 31r.

47. *Virgin and Child with Saint John the Baptist and Saint Joseph*
Red chalk. 290 × 204 mm.

The drawing borrows its composition from the "Virgin and Child with Saint John" of the *Altar-piece of Saint Anne*, commissioned in 1510 to Fra Bartolommeo for the Sala dei Cinquecento in the Palazzo della Signoria in Florence. It was probably a preparatory drawing for a painting by a friend of Michelangelo's, perhaps Bugiardini or Michele di Ridolfo. Prov.: Early seventeenth-century French collector – E. Jabach (?); introduced in the Cabinet du Roi at an unknown date. Inv. 692. JOANNIDES 2003, n. 32v.

48. *Virgin and Child with Saint John the Baptist*
Red chalk. 290 × 204 mm.

The posture of the Virgin is reminiscent of that of the *Libyan Sibyl*, painted on the vault of the Cappella Sistina in the Vatican, and of works by Titian or by his workshop (Longleat House and Italy, private collection). But this drawing, obviously subsequent, dates to around 1530. It is no doubt a study for a painting that was to be executed by a friend of Michelangelo's, perhaps Bugiardini or Michele di Ridolfo.
Prov.: Early seventeenth-century French collector – E. Jabach (?) – Introduced in the Cabinet du Roi at an unknown date. Inv. 692. JOANNIDES 2003, n. 32r.

49. *Leda and the Swan*
Red chalk, traces of partial corrections with wash (?) 199 × 295 mm.

Usually excluded from Michelangelo's *œuvre*, except by Thode and Joannides, this drawing is associated with the painting that the artist executed in 1529 – 30 for the Duke Alfonso d'Este. Following a falling out with the duke's emissary, Michelangelo gave the work to his pupil, Antonio Mini, who took it to France and engaged Giuliano Buonaccorsi to sell it to François I.
Prov.: Unidentified early seventeenth-century French collector – E. Jabach (?) perhaps part of his 'second' collection – Saint-Morys; confiscation of the property of the Émigrés in 1793, entrusted to the Muséum central des Arts in 1796-1797. Inv. 815, JOANNIDES 2003, n. 33.

50. *Seated Virgin and Child, seen in left profile*
Red chalk. 189 × 101 mm.

Fragment of a sheet, of which plate 51 shows another piece. The original state of the sheet is known by a copy preserved in the Louvre (Inv. 807). This drawing was probably not connected with any specific design, but perhaps executed to be given to a pupil, or to another artist.
Prov.: E. Jabach, drawing catalogued as "remainder" – Purchased for the Cabinet du Roi in 1671. Inv. 691. JOANNIDES 2003, n. 34.

51. *Seated Virgin and Child; fragment of drapery*

Red chalk. 170 × 110 mm.

Fragment of a sheet, of which plate 50 shows another piece. The original state of the sheet is known by a copy preserved in the Louvre (Inv. 807). This drawing was probably not connected with any specific design, but perhaps executed to be given to a pupil, or to another artist.
Prov.: E. Jabach, drawing catalogued as "remainder" – Purchased for the Cabinet du Roi in 1671 (?). Inv. 703. JOANNIDES 2003, n. 35.

52. *Three men carrying a body: the Deposition* (?)
Red chalk. 291 × 175 mm.

Dating from approximately 1530, this drawing, the original purpose of which is unknown, was used by Francesco Primaticcio for the *Removal of the bodies of the Suitors* on the wall of the Galerie d'Ulysse in the Château of Fontainebleau. The secondary study seems to be a preparatory drawing for a Nicodemus (in a *Pietà*) or a Saint John (in a *Swooning of the Virgin*).
Prov.: A Mini (?) – Fr. Primaticcio (?) – E. Jabach, drawing catalogued as "remainder" – Purchased for the Cabinet du Roi in 1671. Inv. 704. Joannides 2003, n. 36v.

53. *Virgin and Child with Saint John the Baptist* (?)
Red chalk. 291 × 175 mm.

This study of a Virgin and Child with Saint John the Baptist also presents several features of a sibyl accompanied by a genii, or of a Charity. As well, it inspired various works on this subject. It derives from a Virgin and Child on the Model for the Tomb of the Magnifici (plate 42).
Prov.: A Mini (?) – Fr. Primaticcio (?) – E. Jabach, drawing catalogued as "remainder" – Purchased for the Cabinet du Roi in 1671. Inv. 704. Joannnides 2003, n. 36r.

54. *Resurrection of Christ, with nine guards*
Red chalk. 152 × 169 mm.

This drawing belongs to a set of sixteen preparatory sheets for several *Resurrection* compositions, which have successively been connected with an eventual design for a lunette above the Tomb of the Magnifici, or for the Cappella delle Reliquie in San

Lorenzo, in Florence; the painting was intended for either the entrance wall of the Cappella Sistina in the Vatican, or for an altar-piece that Sebastiano del Piombo was engaged to paint for the Cappella Chigi of Santa Maria della Pace, in Rome. This iconography of the Resurrection, with Christ bursting from the tomb, seems to belong to a Northern tradition. The drawing is a direct preparatory for another, bigger and more finished drawing (now in Windsor) (R.L. 12767).
Prov.: E. Jabach, drawing catalogued as "remainder" – Purchased for the Cabinet du Roi in 1671. Inv. 691bis. JOANNIDES 2003, n. 37.

55. *Dead Christ, and two corrections of the right arm*
Black chalk. 254 × 319 mm.

A drawing executed by Michelangelo to help Sebastiano del Piombo in the painting of a *Pietà* commissioned by Ferrante Gonzaga in 1533 or 1534 for the funerary chapel of Francesco De Los Cobos at San Salvador d'Ubeda, in Andalucia. The painting was not completed until 1539.
Prov.: M. Buonarroti the Younger (?) – J.-B.Wicar – W. Y. Ottley – Sir Th. Lawrence – S. Woodburn – William II, king of the Netherlands – Purchased for the Louvre Museum. Inv. 716. JOANNIDES 2003, n. 38.

56. *Study for the figure on the recto, and a sketch of legs (?)*
Black chalk. 230 × 100 mm.

Presumably part of the same sheet as plate 58. This figure was probably drawn by the artist for his painter friend, Marcello Venusti, to be incorporated into a copy of the *Christ on the Cross with Two Angels* that Michelangelo had drawn for Vittoria Colonna circa 1540. This copy was very likely one of the two paintings commissioned to Venusti (around 1555) by one of Michelangelo's servants, Francesco Amadori, known as *Urbino*.
Prov. E. Jabach, drawing catalogued as "remainder" – Purchased for the Cabinet du Roi in 1671. Inv. 720. JOANNIDES 2003, n. 39v.

57. *The Virgin at the foot of the Cross*
Black chalk. 230 × 100 mm.

Presumably part of the same sheet as plate 58. This figure was

probably drawn by the artist for his painter friend, Marcello Venusti, to be incorporated into a copy of the *Christ on the Cross with Two Angels* that Michelangelo had drawn for Vittoria Colonna (circa 1540). This copy was very likely one of the two paintings commissioned to Venusti (around 1555) by one of Michelangelo's servants, Francesco Amadori, known as *Urbino*.
Prov.: E. Jabach, drawng catalogued as "remainder" – Purchased for the Cabinet du Roi in 1671. Inv. 720. JOANNIDES 2003, n. 39r.

58. *Saint John at the foot of the Cross*
Black chalk. 250 × 85 mm.

Presumably part of the same sheet as plates.56-57. This figure was probably drawn by the artist for his painter friend, Marcello Venusti, to be incorporated into a copy of the *Christ on the Cross with Two Angels* that Michelangelo had drawn for Vittoria Colonna (circa 1540). This copy was very likely one of the two paintings commissioned to Venusti (around 1555) by one of Michelangelo's servants, Francesco Amadori, known as *Urbino*.
Prov.: E. Jabach, drawing catalogued as "remainder" – Purchased for the Cabinet du Roi in 1671. Inv. 698. JOANNIDES 2003, n. 40.

59. *Christ on the Cross* (fragment)
Black chalk. 243 × 131 mm.

Unique among works of its kind in Michelangelo's *œuvre*, this Christ on the Cross, in the throes of death, can only be connected generically with the *Christ on the Cross with Two Angels* that Michelangelo had drawn for Vittoria Colonna (circa 1540). The lower section of this sheet was cut out and joined to another drawing, presently in the Louvre (Inv. 841, n. 94).
Prov.: E. Jabach, drawing catalogued as "remainder" – Purchased for the Cabinet du Roi in 1671. Inv. 842. JOANNIDES 2003, n. 41r.

60. *Christ on the Cross between the Virgin and Saint John (?)*
Black chalk with brown wash and heightening in white. 432 × 289 mm.

This drawing belongs to a series of six (Oxford, Ashmolean Museum, London, British Museum, Windsor, Royal Library), and is perhaps a preparatory for a wooden Crucifix. It seems obvious that it is also a sort of spiritual exercise on the theme of

the redeeming sacrifice. Here, the old man on the right may be a self-portrait. This drawing should probably be dated from between 1562 and Michelangelo's death in February 1564.
Prov.: E. Jabach, drawing catalogued as "remainder" – Purchased for the Cabinet du Roi in 1671. Inv. 700. JOANNIDES 2003, n 42.

61. *Section of the vault designed for the Chapel of the King of France in San Pietro, in Rome*
Black chalk. 131 × 243 mm.

The Chapel of the King of France in San Pietro, in Rome, not having been built according to Michelangelo's instructions, had to be demolished in 1557; the new vault was not completed until 1558. This drawing shows the thickness of the counter-arches, and relates to this reconstruction yard.
Prov.: E. Jabach, drawing catalogued as "remainder" – Purchased for the Cabinet du Roi in 1671. Inv. 842. JOANNIDES 2003, n. 41v.

62. *Study for the casing of a door or a window*
Black chalk, partly ruled, over stylus incisions and compass marks. 197 × 185 mm.

Discovered by Joannides among the drawings of Andrea Boscoli, this partial design of a casing does not accurately match any architecture built on Michelangelo's drawings. Its attribution to the artist remains hypothetical. Yet it presents likenesses with two drawings from his hand preserved at Oxford (Ashmolean, P II 332-333). This sheet was reutilised by Andrea Boscoli who drew on the recto a copy of the *Scourging of Christ*, after an etching of the *Great Passion* by Dürer.
Prov.: Comes from Versailles, according to Morel d'Arleux. Inv. 19086. JOANNIDES 2003, n. 43v.

BIBLIOGRAPHY

BERENSON 1903
B. Berenson. *The Drawings of the Florentine Painters*. 2 vols. London, 1903.

KNAPP 1906
F. Knapp. *Michelangelo*. Stuttgart and Leipzig, 1906.

THODE 1906-1913
H. Thode. *Michelangelo und das Ende der Renaissance. Michelangelo Kritische Untersuchnungen über seine Werke*. 6 vols. Berlin, 1906-1913.

BOROUGH JOHNSON n.d. [1908]
E. Borough Johnson. *The Drawings of Michelangelo*. London, n.d. [1908].

FREY 1909-1911
K. Frey. *Die Handzeichnungen Michelangiolo Buonarrotis. Herausgegeben und mit kritischem Apparate*. Berlin, 1909-1911 (supplementary volume by F. Knapp. Berlin, 1926).

DEMONTS 1922
L. Demonts. *Catalogue des dessins de Michel-Ange, 1475-1564*. Exh. cat. Paris: Musée du Louvre, 1922.

PANOFSKY 1922
E. Panofsky. *Handzeichnungen Michelangelos*. Leipzig, 1922.

KNAPP 1923
F. Knapp. *Michelangelo*. Munich, 1923.

BRINCKMANN 1925
A. E. Brinckmann. *Michelangelo Zeichnungen*. Munich, 1925.

POPP 1925-1926
A. E. Popp. "Bermerkungen zu einigen Zeichnungen Michelangelos." *Zeitschrift für Bildende Kunst*, n.s LIX, 1925-1926, I-II, pp. 134-146 ; III, pp. 169-74.

TOLNAY 1927
Ch. de Tolnay (K. Tolnai). "Die Handzeichnungen Michelangelos im *Codex Vaticanus*." *Repertorium für Kunstwissenschaft*, XLVIII, 3, 1927, pp. 157-205.

PANOFSKY 1927-1928
E. Panofsky, "Kopie oder Falschung? Ein Beitrag zur Kritik einiger Zeichnungen aus der Werkstatt Michelangelos." *Zeitschrift für Bildende Kunst*, n.s. LXI, 6, 1927-1928, pp. 221-44.

POPP 1927-1928
A. E. Popp. "Fälschliche Michelangelo zugeschreiben Zeichnungen." *Zeitschrift für Bildende Kunst*, n.s. LXI, 1927-1928, p. 8-17

TOLNAY 1928
Ch. de Tolnay (K. Tolnai). « Die Handzeichnungen Michelangelos im Archivio Buonarroti." *Münchner Jahrbuch der Bildenden Kunst*, n.s V, 4, 1928, pp. 377-476.

POPHAM 1930
A. E. Popham. *Michelangelo (Master Draughtsman no. 1)*. London and New York, 1930.

BAUMGART 1937
F. Baumgart. "Die Jugendzeichnungen Michelangelos bis 1506." *Marburger Jahrbuch für Kunstwissenschaft*, X, 1937, pp. 1-54.

BERENSON 1938
B. Berenson. *The Drawings of Florentine Painters*. 3 vols. 2nd edition. Chicago, 1938.

DELACRE 1938
M. Delacre. *Le Dessin de Michel-Ange*. Brussels, 1938.

TOLNAY 1943
Ch. de Tolnay. *The Youth of Michelangelo*. Princeton, 1943.

TOLNAY 1945
Ch. de Tolnay. *Michelangelo II: The Sistine Chapel*. Princeton, 1945.

TOLNAY 1948
Ch. de Tolnay. *Michelangelo III: The Medici Chapel*. Princeton, 1948.

GOLDSCHEIDER 1951
L. Goldscheider. *Michelangelo Drawings*. London, 1951.

WILDE 1953
J. Wilde. *Italian Drawings in the Department of Prints and Drawings in the British Museum. Michelangelo and his Studio*. London, 1953.

TOLNAY 1954
Ch. de Tolnay. *Michelangelo IV: The Julius Tomb*. Princeton, 1954.

DUSSLER 1959
L. Dussler. *Die Zeichnungen des Michelangelo, Kritischer Katalog*. Berlin, 1959.

TOLNAY 1960
Ch. de Tolnay. *Michelangelo V: The Final Period*. Princeton, 1960.

BERENSON 1961
B. Berenson. *I Disegni dei Pittori Fiorentini*. 3 vols. 3rd edition. Milan, 1961.

BAROCCHI 1961-1962
P. Barocchi. *Mostra di disegni di Michelangelo*. Exh. cat. Florence: Gabinetto Disegni e Stampe degli Uffizi, 1961-1962.

BAROCCHI 1962
P. Barocchi. *Michelangelo e la sua scuola, I disegni di Casa Buonarroti e degli Uffizi*. 2 vols. Florence, 1962.

BAROCCHI/VASARI 1962
G. Vasari, edited by P. Barocchi. *La Vita di Michelangelo nelle redazioni del 1550 e 1568*. 5 vols. Milan, 1962.

HIRST 1963
M. Hirst. "Michelangelo Drawings in Florence." *The Burlington Magazine*, CV, 721, April 1963, pp. 166-71.

BAROCCHI 1964a
P. Barocchi. *Michelangelo e la sua scuola, I disegni dell'Archivio Buonarroti*. Florence, 1964.

BAROCCHI 1964b
P. Barocchi, *Michelangelo, mostra di disegni, manoscritti e documenti*. Exh. cat. Florence: Casa Buonarroti/Biblioteca Laurenziana, 1964.

TOLNAY, SALMI, and BAROCCHI 1964
Ch. de Tolnay, M. Salmi and P. Barocchi. *Disegni di Michelangelo: 103 disegni in facsimile*. Milan, 1964.

HARTT 1971
F. Hartt. *The Drawings of Michelangelo*. London, 1971.

BACOU and VIATTE 1975
R. Bacou and F. Viatte. *Michel-Ange au Louvre – les dessins*. Exh. cat. Paris: Cabinet des dessins, Musée du Louvre (*Le Petit journal des grandes expositions*), 1975

GERE and TURNER 1975
J.A. Gere and N. Turner. *Drawings by Michelangelo in the Collection of her Majesty the Queen at Windsor Castle, The Ashmolean Museum, The British Museum and other English Collections*. Exh. cat. London: Department of Prints and Drawings, The British Museum, 1975

HARTT 1975
F. Hartt. *Handlist of Newly Accepted Drawings by Michelangelo*. London, 1975.

JOANNIDES 1975
P. Joannides. "Michelangelo Drawings in the British Museum." *The Burlington Magazine*, CXVII, 865, April 1975, pp. 257-62.

TOLNAY 1975-1976
Ch. de Tolnay. *I disegni di Michelangelo nelle collezioni italiane*. Exh. cat. Florence: Casa Buonarroti/Galleria degli Uffizi, 1975-1976

TOLNAY 1975-1980
Ch. de Tolnay. *Corpus dei Disegni di Michelangelo*. 4 vols. Novara, 1975-1980.

WILDE 1978
J. Wilde. *Michelangelo, Six Lectures*. Oxford, 1978.

ANNESELY and HIRST 1981
N. Annesely and M. Hirst. "*Christ and the Woman of Samaria* by Michelangelo." *The Burlington Magazine*, CXXIII, 943, October 1981, pp. 608-614.

JOANNIDES 1981
P. Joannides. "Ch. de Tolnay, *Corpus dei Disegni di Michelangelo*." *Art Bulletin*, LXIII, 4, October 1981, pp. 679-87.

HIRST 1983
M. Hirst. "Charles de Tolnay, *Corpus dei Disegni di Michelangelo*." *The Burlington Magazine*, CXXV, 966, September 1983, pp. 551-6.

HIRST 1988
M. Hirst. *Michelangelo and His Drawings*. London, 1988.

HIRST 1988-1989
M. Hirst. *Michelangelo Draughtsman/Michel-Ange dessinateur*. Exh. cat. Washington: National Gallery of Art, 1988; Paris: Musée du Louvre, 1989 (with insert).

CORDELLIER 1991
D. Cordellier. "Fragments de jeunesse: deux dessins inédits de Michel-Ange au Louvre." *La Revue du Louvre et des musées de France*, XLI, 2, 1991, pp. 43-55.

JOANNIDES 1992
P. Joannides. "Amputating Michelangelo's Corpus." *Apollo*, CXXXV, 362, April 1992, pp. 265-6.

JOANNIDES 1994
P. Joannides. "À propos d'une sanguine nouvellement attribuée à Michel-Ange (1475-1564). La connaissance des dessins de l'artiste en France au XVIe siècle." *La Revue du Louvre et des musées de France*, XLIII, 3, June 1994, pp. 15-29.

HIRST 1994-1995
M. Hirst. "The Artist in Rome, 1496-1501." In *Making and Meaning: The Young Michelangelo*. Exh. cat. London: National Gallery, 1994-1995, pp. 13-82.

JOANNIDES 1996-1998
P. Joannides. *Michelangelo and His Influence; Drawings from the Royal Collection, Windsor Castle*. Exh. cat. Washington: National Gallery of Art; Fort Worth: Kimbell Art Museum; Chicago: The Art Institute; Cambridge: Fitzwilliam Museum; London: The Queen's Gallery, Buckingham Palace, 1996-1998

TURNER, HENDRIX, and PLAZZOTTA 1997
N. Turner, L. Hendrix and C. Plazzotta. *European Drawings.
3. Catalogue of the Collections, The J. Paul Getty Museum.*
Los Angeles, 1997.

STOCK 2000
J. Stock. "Rediscoveries: Michelangelo". *FMR International*,
104, June-July 2000, pp. 20-4.

JOANNIDES 2001
P. Joannides. "On Michelangelo's *Stoning of St Stephen." Master
Drawings*, XXXIX, 1, Winter 2001, pp. 3-11.

PY 2001
B. Py. *Everhard Jabach collectionneur (1618-1695). Les dessins de
l'inventaire de 1695.* Paris, 2001.

CLIFFORD 2002
T. Clifford. "A Candelabrum by Michelangelo: A Discovery at
the Cooper-Hewitt, National Design Museum in New York."
Apollo, CLVI, 487, September 2002, pp. 30-40.

JOANNIDES 2003a
P. Joannides. *Michel-Ange, élèves et copistes (Musée du Louvre.
Musée d'Orsay. Département des Arts graphiques. Inventaire géné-
ral des dessins italiens, VI).* Paris, 2003.

JOANNIDES 2003b
P. Joannides. "Unconsidered Trifles: Copies after Lost Drawings
by Michelangelo and Their Evidential Value." *Paragone*, 2003
(forthcoming).

Photographic Credits

RMN/Michèle Bellot: no. 8, 9, 19, 22, 24, 33, 34, 36, 41, 42, 43, 44, 47, 48; RMN/J. G. Berizzi: cover, no. 31, 40, 49, 54, 61;
RMN/Gérard Blot: p. 2, no. 3, 11, 58, 60; RMN/Le Mage: no. 1, 2, 4, 5, 6, 7, 10, 12, 13, 14, 15, 16, 17, 18, 20, 21, 23, 25, 26,
27, 28, 29, 30, 32, 35, 37, 38, 39, 45, 46, 50, 51, 52, 53, 55, 56, 57, 59, 62

Paper
This book is printed on Satimat naturel 170 g;
cover: ArjoWiggins Impressions Keaykolour Nature Schiste 250 g

Colour Separation
Galasele, Milan

Printed March 2003
by Leva Arti Grafiche, Sesto San Giovanni, Milan, Italy,
for the Musée du Louvre, Paris, and for 5 Continents Editions, Milan